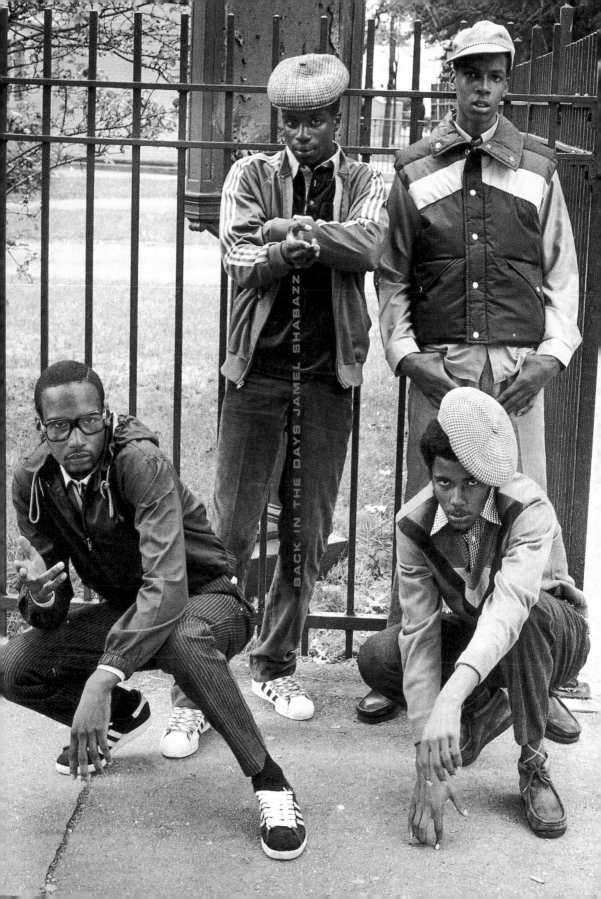

BACK IN THE DAYS JAMEL SHABAZZ

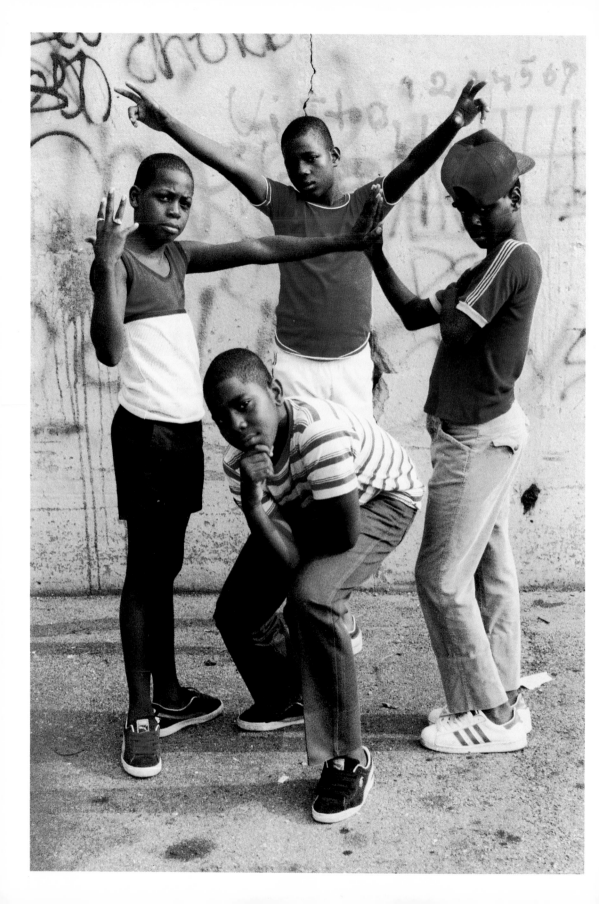

This book is dedicated to my mother and my wife
for their constant encouragement and understanding.

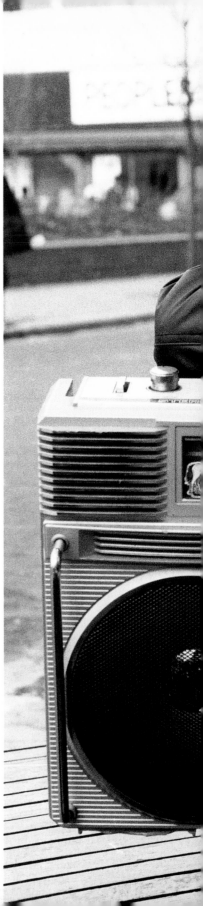

PHOTOGRAPHS: JAMEL SHABAZZ INTRODUCTION: FAB 5 FREDDY ESSAY: ERNIE PANICCIOLI

POWERHOUSE BOOKS
NEW YORK, NY

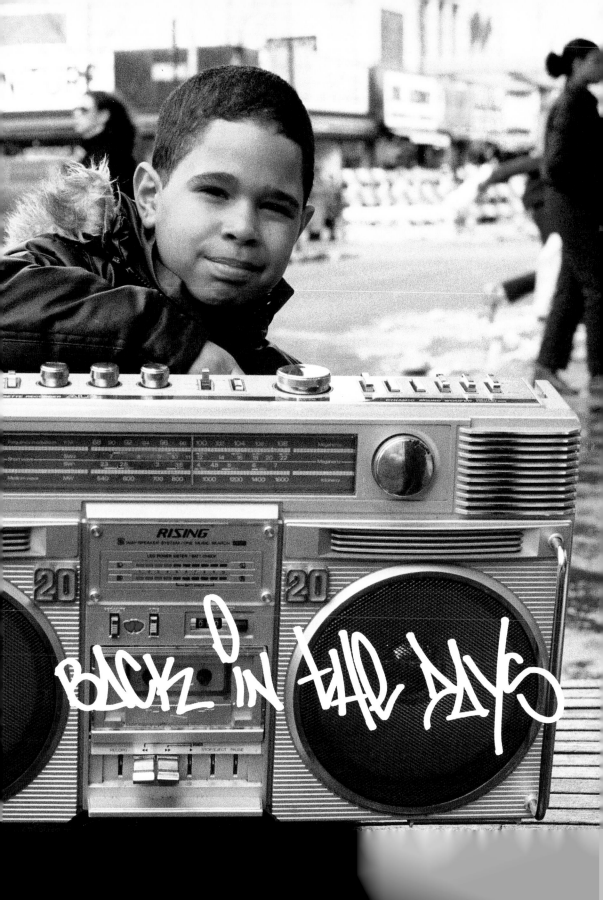

aka **FAB 5 FREDDY**

FRED BRATHWAITE

Great photography captures the spirit of the times and places you right in the middle of an experience. When the visual is right, you can just about sense the smells, sounds, tastes, and textures. It will remind you of how things used to be. Indeed, *Back in the Days* takes me back to the 80s. Back to the faces that inspired me and to the people I grew up with. They look like we looked, dress like we dressed, and pose like we posed. These were my friends, heroes, and contemporaries. These are the faces of the generation that gave birth to hip hop—not only the most dominant and inclusive youth culture in history, but also the most stylishly innovative and consistently advanced generation since the Rock 'n Roll era. Like Leni Riefenstahl's lionizing portraits in her books *The Last of The Nuba* and *The People of Kau*, Jamel Shabazz has assembled his images into the most complete and comprehensive body of work of its kind.

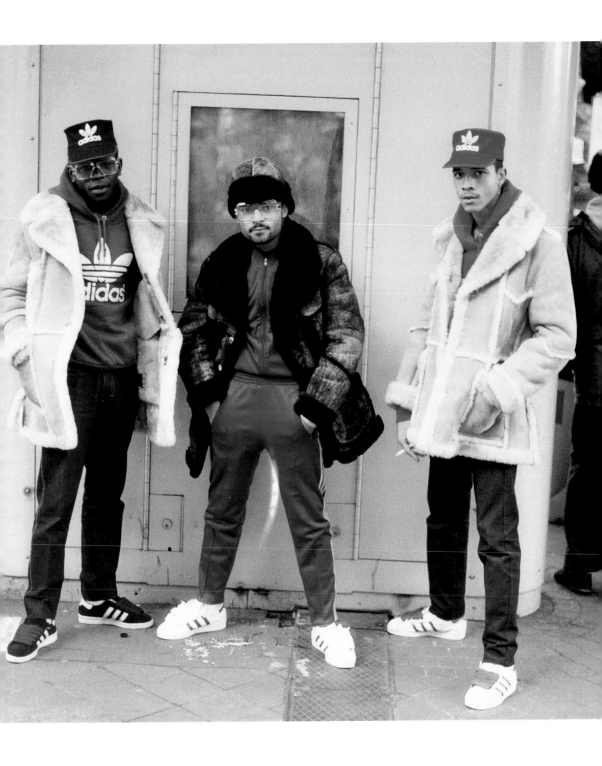

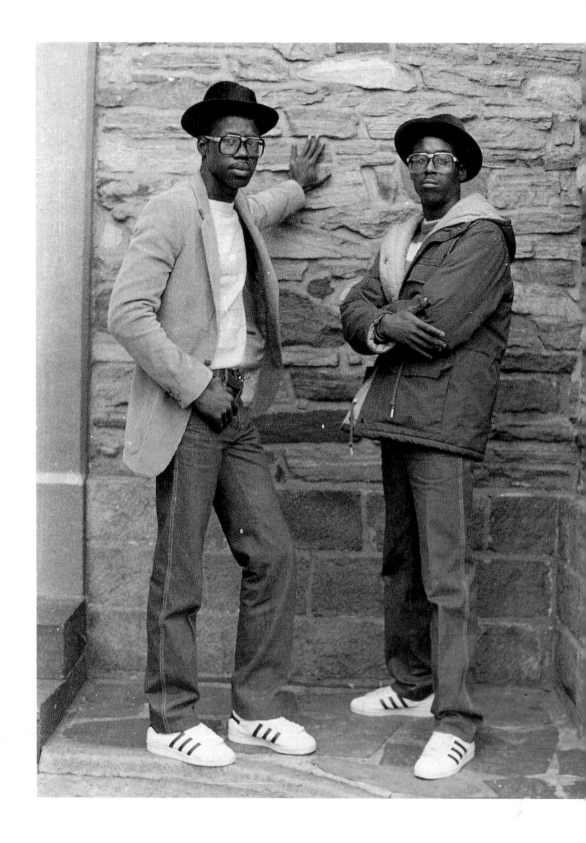

If among the many emotions you feel while viewing these photos, cool comes to mind, here's why—back then, cool was all about having the right flavor and *savoir faire*. Such a style blended a certain brand of rebelliousness with a casual nonchalance. It was a cocky confidence of sorts that was meticulously updated by a perpetual pursuit of an alternative, yet distinctive sensibility. Cool permeated the scene. Kool Herc, LL Cool J, Cool Rock Ski, and Kool Moe Dee were but a few of the countless numbers who added the word cool to their street, graffiti, DJ, MC, and break-dancer names. But cool back then went beyond the Kangols, Adidas, gold chains, monikers, and the sheer superficiality of our current "bling bling" counterculture. It went much deeper. It wasn't about being in a fashion show, going double platinum, or selling the next urban brand. Cool was—and in many cases still is—about survival. Like the images Jamel shows us, cool was about strength, pride, courage, and a fierce love for self.

What is cool? Robert Farris Thompson writes in his 1983 book *Flash of the Spirit* that cool originated in Nigeria in the first half of the 15th century. Ewure was the name given to a ruler crowned King of the Nigerian Empire of Benin. At the time the word literally meant, "it is cool." Thompson writes that Nigerian civilization was impressive not only for its urban density, refinement, and complexity, but also for the inner momentum of conviction and poise they maintained in the face of ongoing political oppression. Other leaders followed suit. Later in that century, a Yoruba leader from Ilobi (an area that is now southern Egabado) decided on the name Oba tio tutu bi asum, which means "Cool-and-peaceful-As-the-native-Herb-Osun." Thompson discovers cool in these different black civilizations and attributes them to a special inner drive and confidence that kept these civilizations going, not unlike the will of those featured in Jamel's work.

The images portrayed in *Back in the Days* illustrate the masks of strength or the "cool pose" that authors Richard Majors and Janet Mancini Bilson discuss in their landmark 1992 book of the same name. In *Cool Pose*, they bring the definition of cool up to date. The "cool pose," they write, "is a ritualized form of masculinity that entails behavior, scripts, physical posturing, impression management, and carefully crafted performances that deliver a single critical message: pride, strength, and control." They go on to say that by acting calm, emotionless, fearless, aloof, and tough, the African American male shows both the dominant culture and the black male himself that he is strong and proud. He is somebody. He is a survivor in spite

of the systematic harm done by the legacy of slavery and the realities of racial oppression or the centuries of hardships and mistrust. For sure, the cool pose represented a way for many young brothers to defend themselves against the indignities and inequities of ghetto life.

There was also a political aspect to cool that came out of the monumental struggle for racial justice and equality: the era when black had officially become beautiful, the afro hairdo, the soul brother handshake, the Superfly Mack Daddy Shaft style, as well as dashikis among many other things African. Cool was also defined by the revolutionary icons of the Black Panther Party like Huey Newton and Stokely Carmichael. When this militant movement was infiltrated and brought down by the FBI in the late 60s and early 70s, drug dealers and gang-bangers were seemingly given free reign to become the new inner-city inspiration in big cities like New York, Los Angeles, and Chicago. These events were heavily filmed and televised and provided the political and social backdrop for those coming up in Shabazz's pictures.

Right about this time, a cultural revolution, later to be defined as hip hop, was taking shape. Many of those gang-banging in New York City delved into this new cool form of urban social activity. This became a defining part of the hip hop culture. Run-DMC's proclamation in their debut single, "Sucker M.C.s," of how they "chill at a party in a 'b-boy' stance" became one of the many lyrics which helped explain the movement to others. Brothers don't stand like that any more. The styles have changed but that hard rock icy cool pose is still in effect.

Shabazz captures the energy, pride, and attitude that gave birth to hip hop culture. He lets us see the spirit of the early hip hop M.C.s who would holla', "Wave your hand in the air, and act like you just don't care!" at every party and the people that participated in the now legendary street jams where DJs like Grand Master Flowers (the first hip hop grand master), Pete DJ Jones, Grand Wizard Theodore, Afrika Bambaataa, Master D, Divine Sounds, the Disco Twins and countless others tapped into street lamps for power and rocked in the city's parks through long hot summer nights. Shabazz seizes the moment when the 007 knife became the 9mm automatic pistol. When black became "urban"—a verbal loophole for corporations to market black style, music, and attitude and not call it "black:"

There's a soundtrack to these photographs that must be heard while viewing. For most, these tunes are there in your head. They include the best of James Brown, Kool and The Gang, George Clinton, Rick James, the Philly Sounds of Gamble and Huff, Harold Melvin, Teddy Pendergrass, Gil Scott-Heron and a song appropriately titled "Love Is The Message" by Philly's MFSB that bridged the transition from disco to the beginnings of hip hop. One of the unsung fathers of the transition is the late great Frankie "Hollywood" Crocker from New York's WBLS FM—everybody cool's favorite radio station back then. That's what's coming out of those big bad ghetto blasters depicted in several of the photos.

A few of Jamel's subjects are lambs—soft, young, and innocent. But most are lions and tigers, sharks and eagles, commanding and controlling every inch of space they occupy. Shabazz also gives us an insight into a generation that took the bait called crack cocaine which emerged in the early 80s, a deliverance deceptively packaged with razor sharp hooks designed to mutilate, shred, destroy and imprison. Hence, a huge portion of those featured in this book languish behind the walls of the U.S. prison industrial complex.

Jamel Shabazz was born and bred in the streets of Brooklyn in the early 60s. His passion for photography and love for his people led him to become a samurai soldier armed with a camera capturing the cool truth. He sliced into the soul of New York City's warriors, generals, warlords, pirates, queens, and victims revealing their classic afro-modern style. Inasmuch as Shabazz observed his subjects, he was also at one with them. "Excuse me brother, may I take your picture?" would be his typical opening line. If any apprehension arose, he would whip out a handy photo album of his work, showing them how wonderful they would look and promising to send a print. If they agreed, he'd take pictures and they would talk about life over a quart of orange juice.

Jamel's friends were eager participants in his developing craft. They would chip in for beer and also take up a collection for film. In return, they added pictures to their now growing photo albums. Jamel traveled to various popular high schools in Brooklyn all the while making friends and influencing people. Then he hit Downtown Brooklyn's Fulton Street, a shopping mecca and hang out for the borough's stylish denizens. Bigger leaps would take him across the Brooklyn Bridge to Delancey

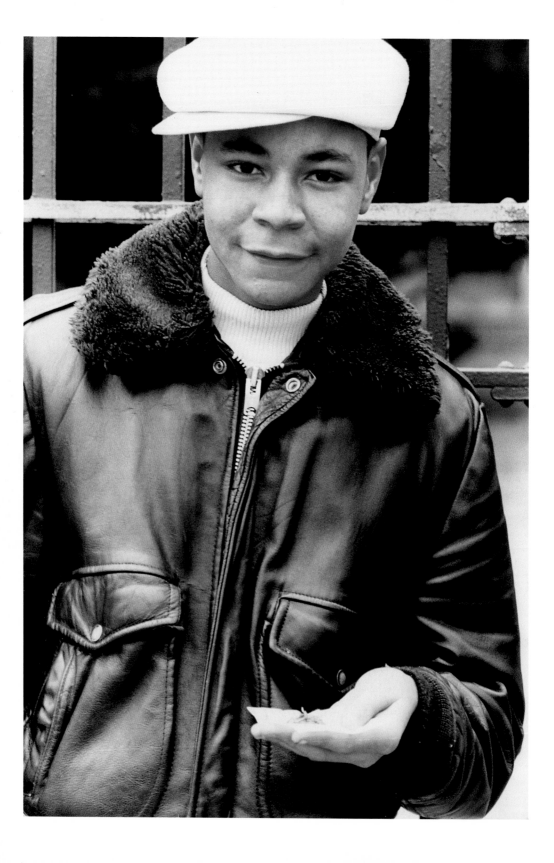

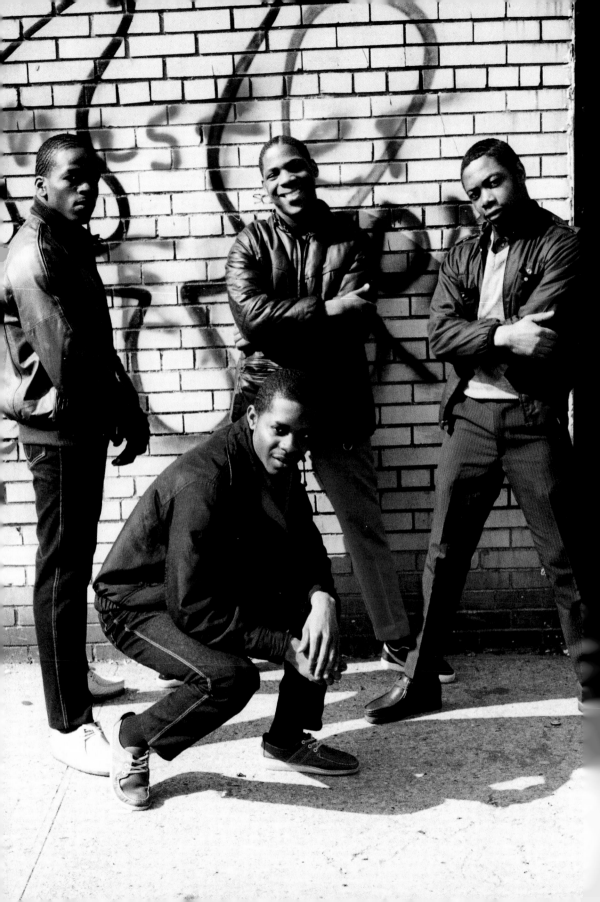

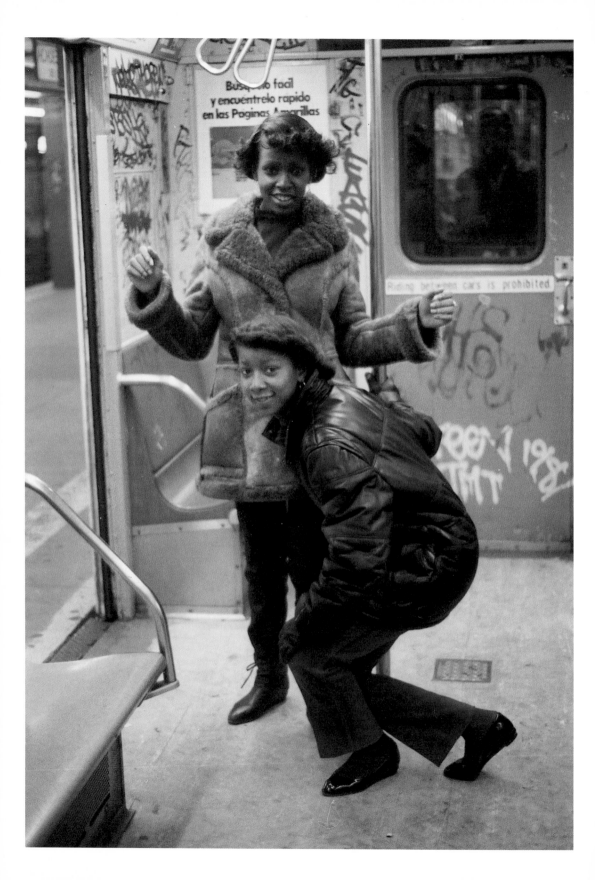

Street on the Lower East Side and then 42nd Street in Times Square where he was now photographing the flavors from the five boroughs and beyond.

His approach to photography was a lot like that of his peers actively caught up in the graffiti wave at the time. His major satisfaction was continuing with what he called his "visual diary."

The thrill of waiting for a new roll of films to develop was akin to his graffiti-writing homies awaiting the freshly painted trains to zip into the station with their latest work for all to see. Taking pictures for Jamel then developed into a way for him to reach out, touch, and influence people. He noticed that the conversations he had with his subjects were having a positive effect on some. Former subjects would thank him for the time, insight, encouragement, and inspiration he blessed them with. "Because of you I took the test for a civil servant job, and got it." "Because of you, I went back to school and got my Associate's Degree." "Because of you, I realized that a life of crime will lead me no where and it's time to stop falling victim to that trap laid for blacks and Latinos."

Now, it's the dawn of this new millennium, California's notorious Bloods and Crips gangs have taken root in some of New York City's poorest ghetto communities and housing projects. While not yet as deadly as their Californian counterparts, Jamel feels a need to take his cameras to this new battle front and reach out to "generation next." Many of them are lost and angry, desperate and dangerous. Most, now in their teens and early twenties, are the sons and daughters of people just like the ones you see in these pictures captured in the 1980s. They are the offspring of young parents trapped in a downward spiral flushed by the system into a shitty abyss.

Only Jamel Shabazz could have taken these pictures. A man not just obsessed with the wonders and science of photography, but a man in love with his people. Some of these individuals, frozen by his lens were the most feared, loved, and respected in the borough of Brooklyn and beyond. Jamel smoothly won them over with his honesty, sincerity, and some orange juice. "Yes, capture my glorious flavor on film so my magnificent image can carry on." "Yes, let me pose and profile in unique and innovative ways." Thanks to the work of Jamel Shabazz, this flavor will live on. And always be cool.

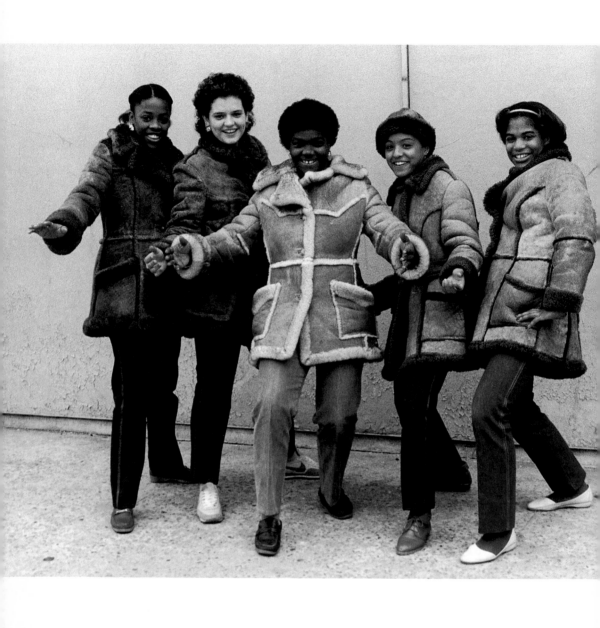

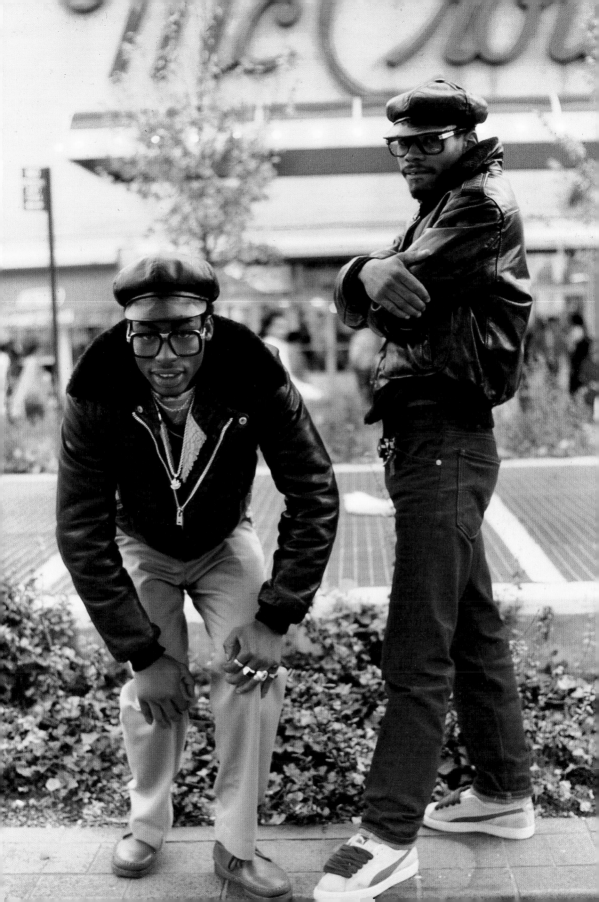

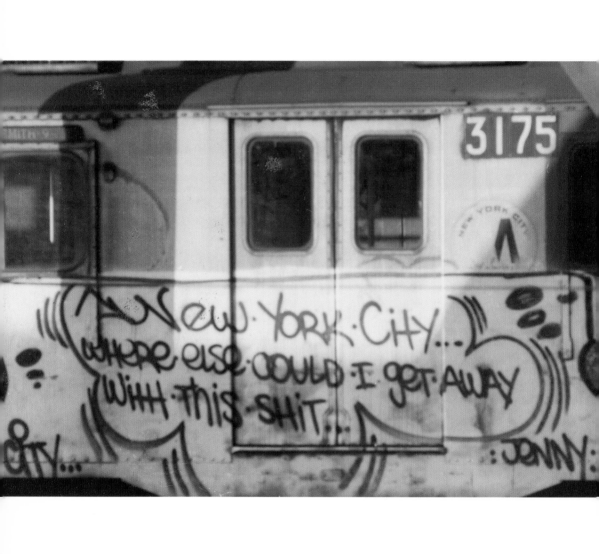

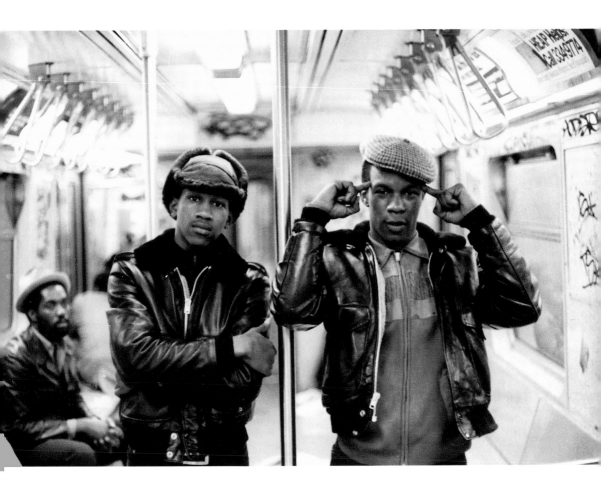

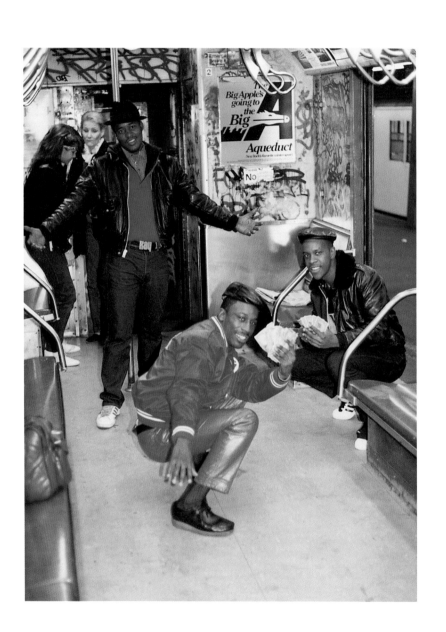

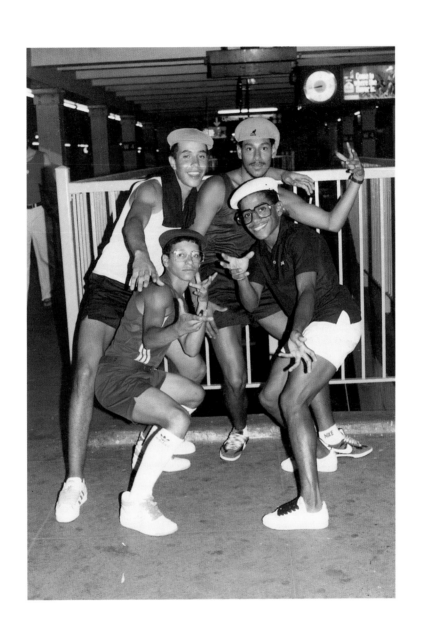

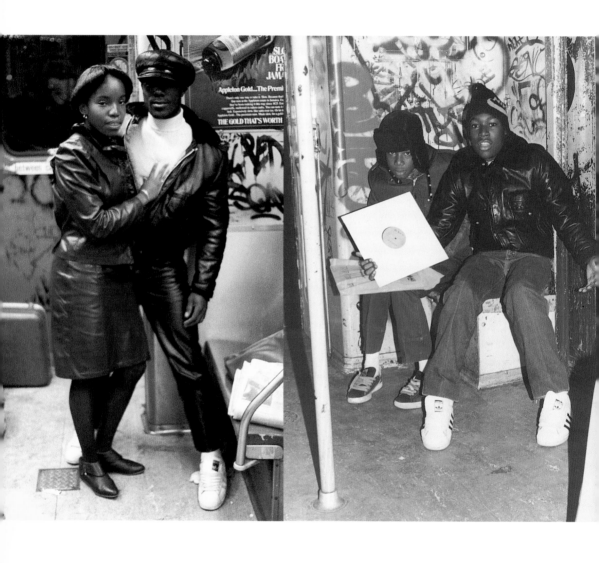

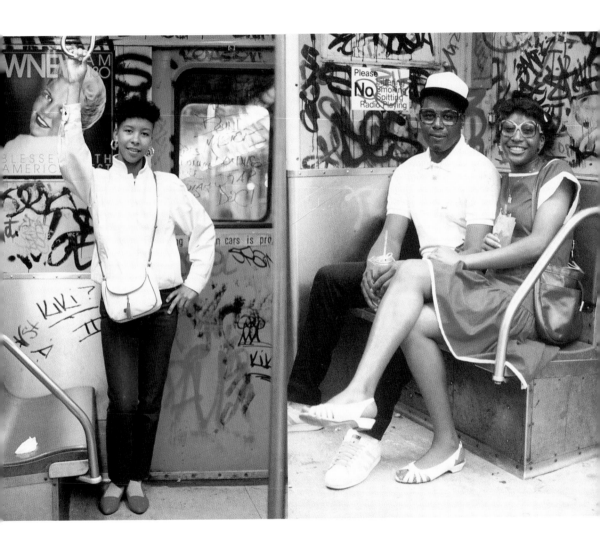

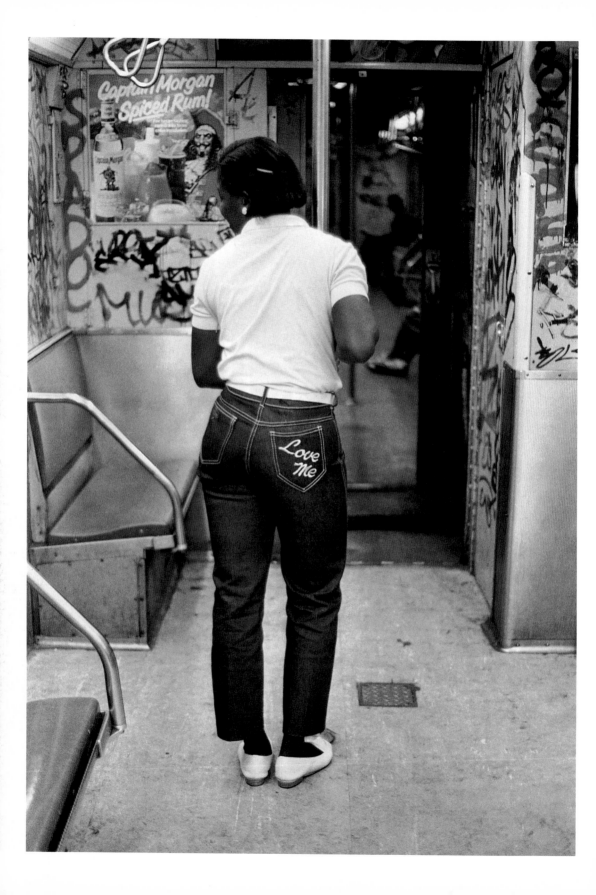

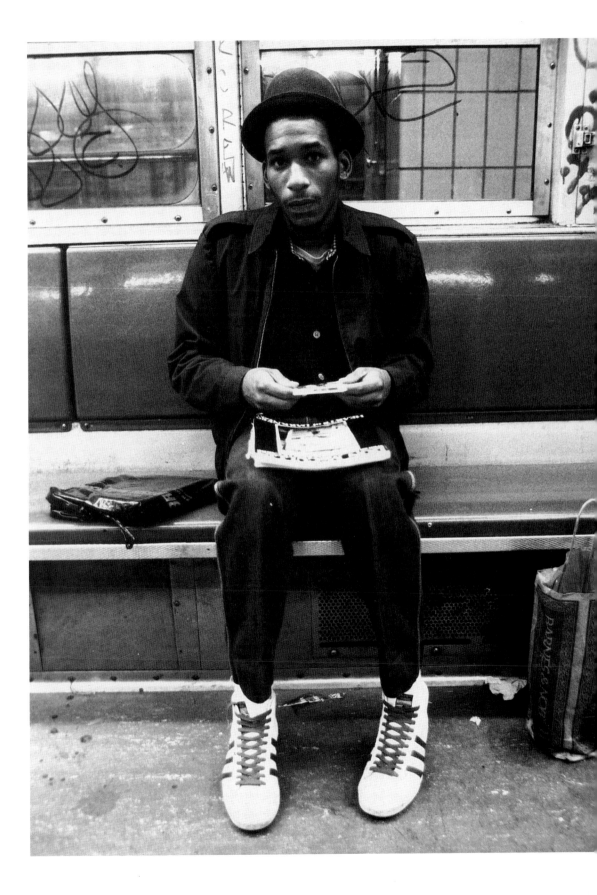

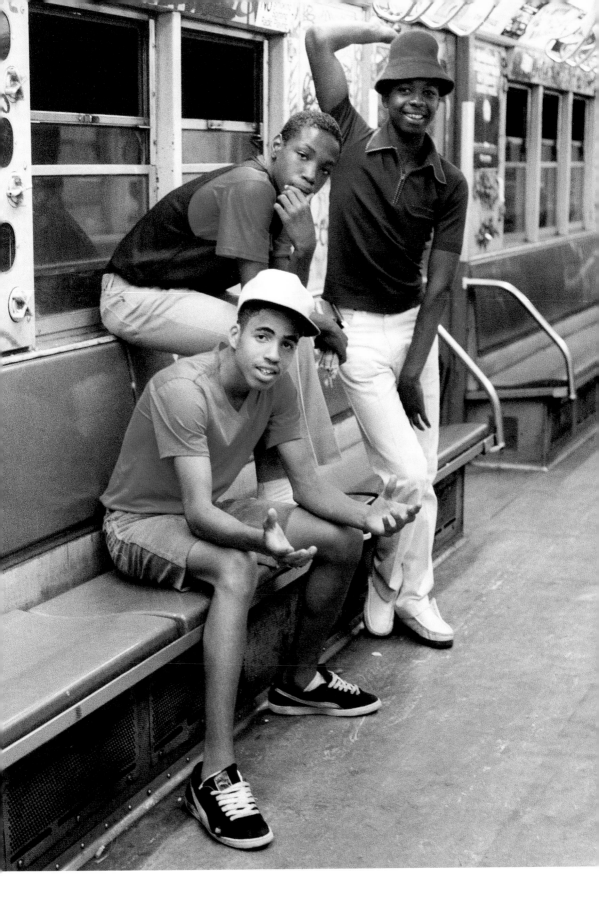

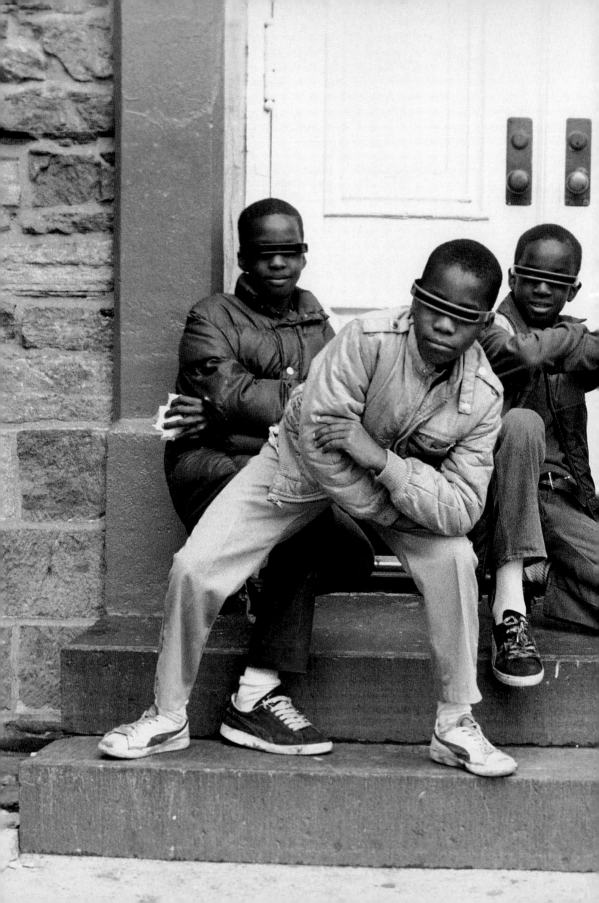

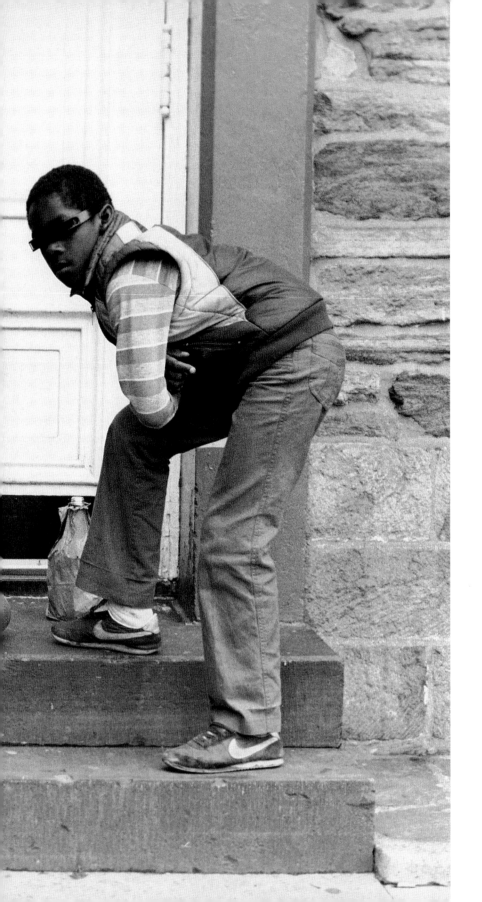

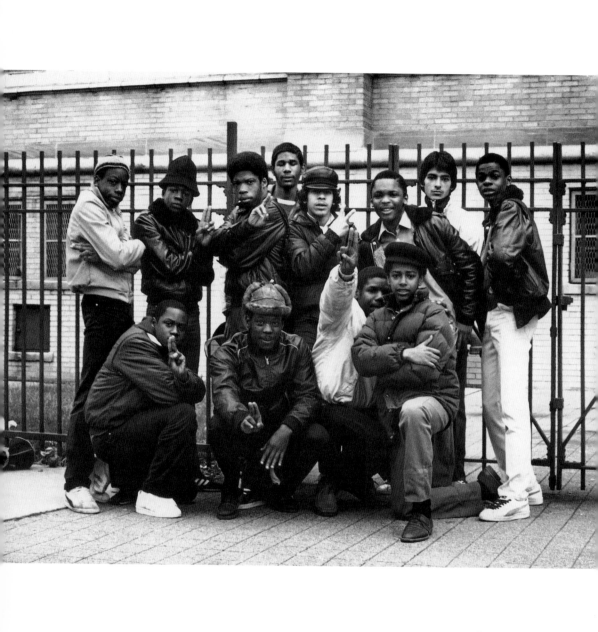

"THE GOVERNMENT YOU HAVE ELECTED IS INOPERATIVE..."

from KRS-1's "Why Is That?" booming from someone's ride, the volume suddenly waking you from your thoughts, making you think back to the last time you spoke with KRS-1 and how true his words are. Making you also silently wish that there were a thousand like him, and realizing that there are. You just have to know where to look, and to recognize truth when you see and hear it.

Jamel's work is like that. His work is that voice that wakes you up gently, suddenly, and like any great artist makes you see things with fresh eyes. Jamel's art is a black mirror, reflecting where we've been, where we are, and where we may be headed.

Too much art, especially photographic art, is done in the safe, sterile confines of a studio; this may help make it technically competent and maybe interesting, but it is seldom valid. Jamel's art is valid because it is truly democratic—of the people, for the people, and by one of the people. His work is true Black art: images of people of color by a man of color who loves his people, and does not fear them, but fears for them.

He uses his camera like KRS-1, Chuck D, or Gil Scott-Heron use their microphones: to reflect a culture, and the hopes, dreams, nightmares, and histories of a people.

Jamel uses the streets as a canvas; his art shows the sight, sound, and smell of Urban America at its richest and fullest, deepest and saddest. When I first saw Jamel's images, and after drinking in the body of his work, I was stunned. I realized he had captured a people at a period of time. His work was strong, valid, and yes, beautiful.

We should look forward to the day when there are many of his books in print, many exhibitions of his work in galleries and museums, and a time when America admits it has another Strong Black Artist in its midst.

Peace Bro.

ERNIE PANICCIOLI
March, 2001

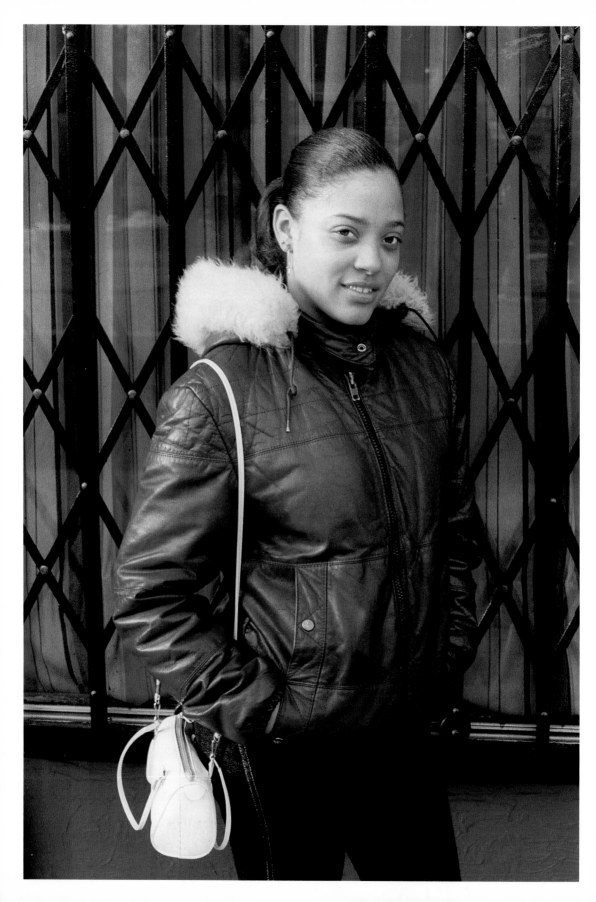

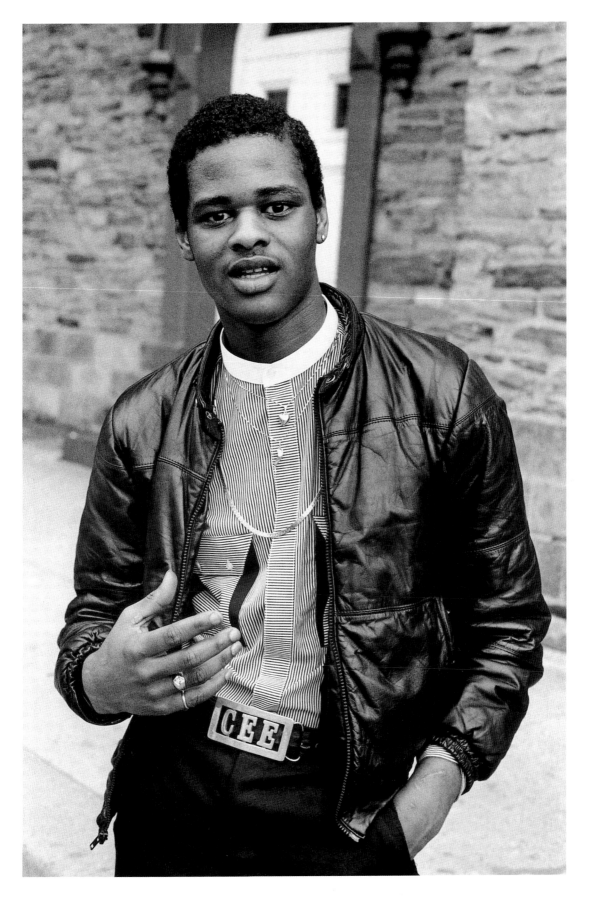

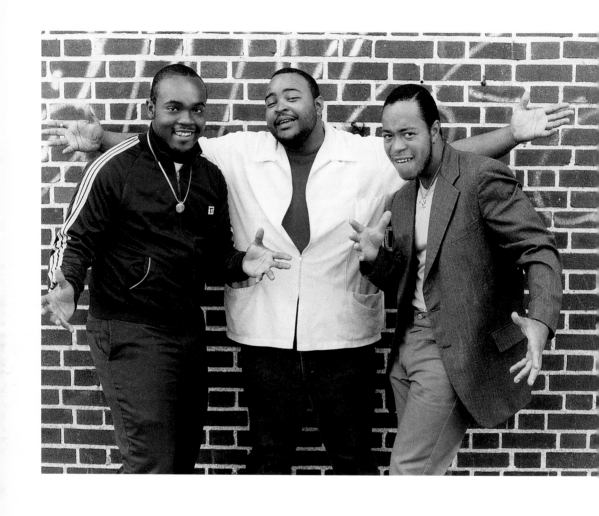

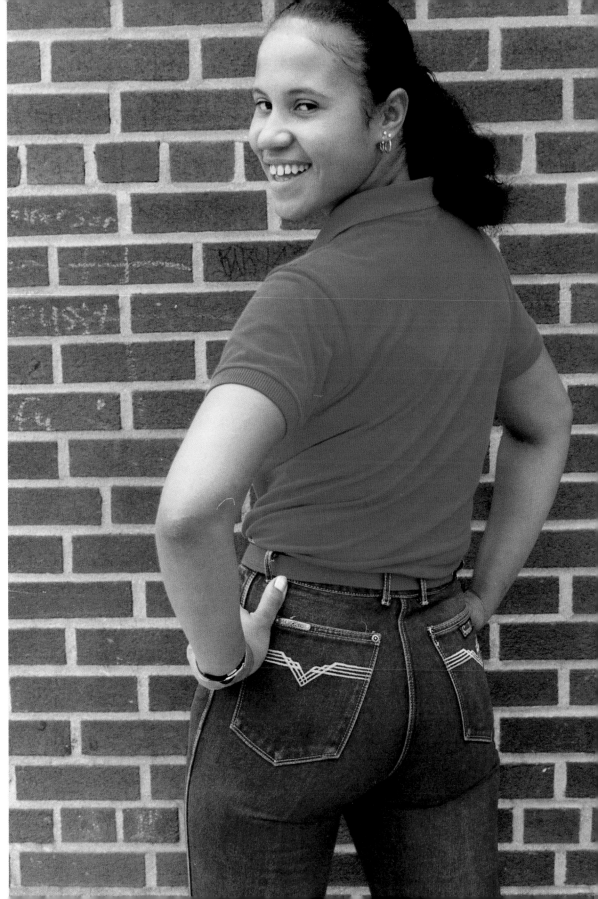

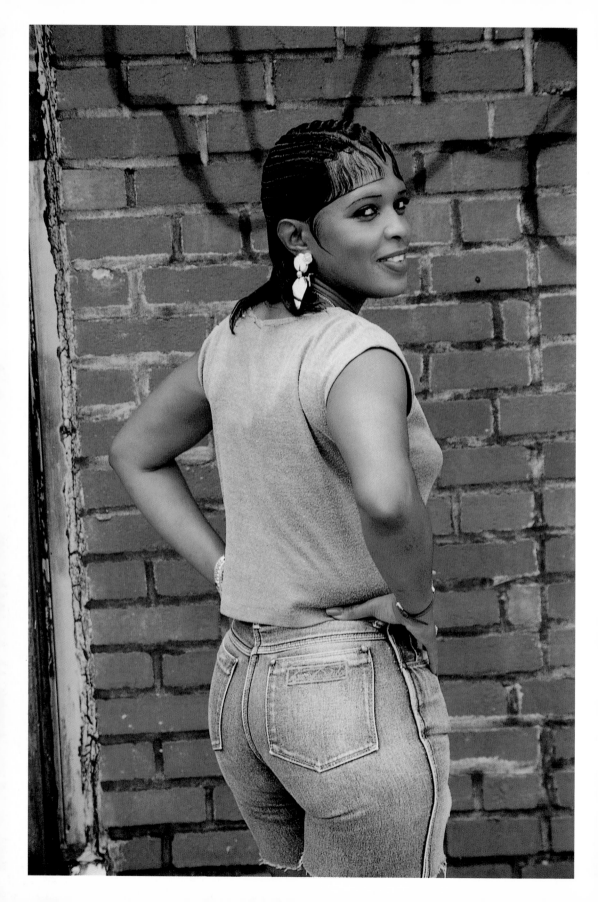

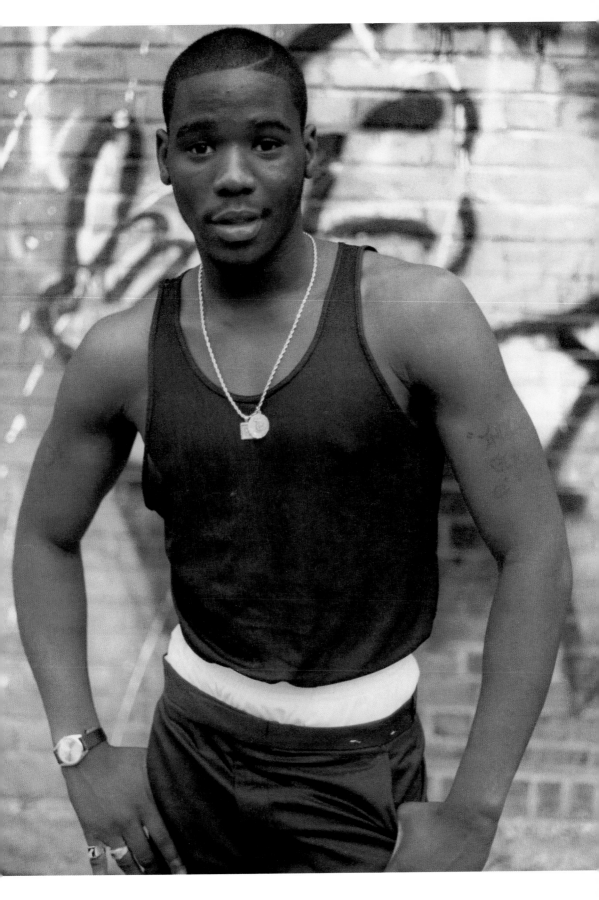

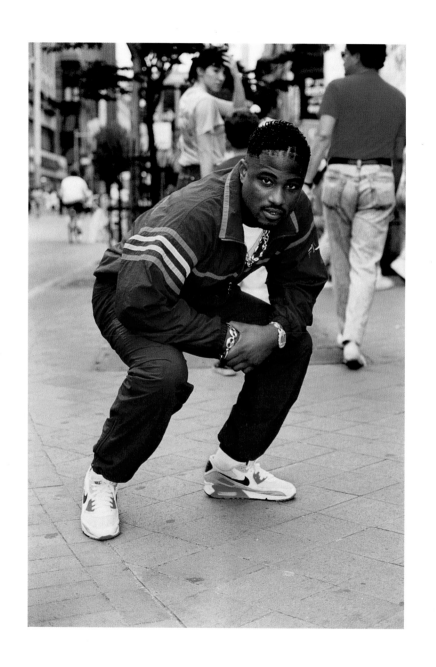

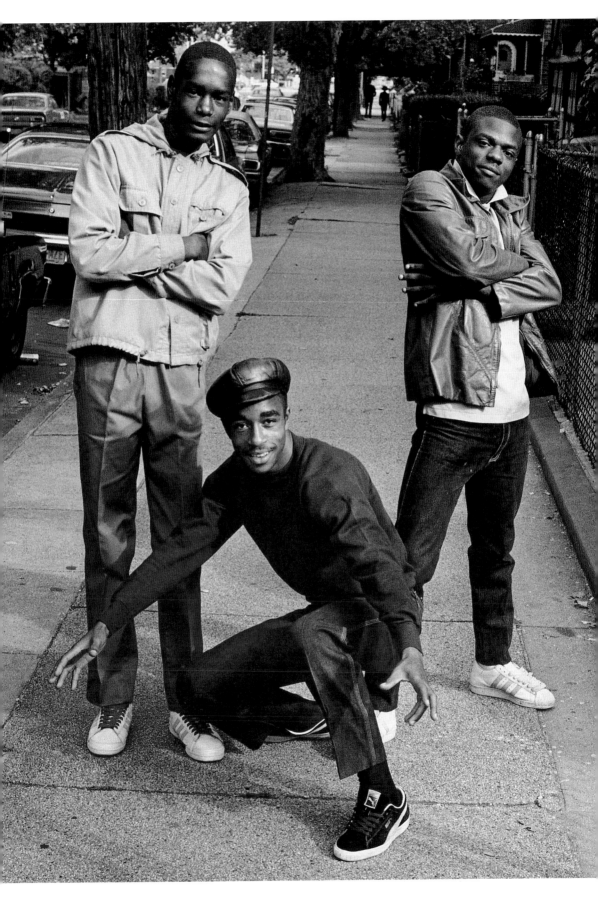

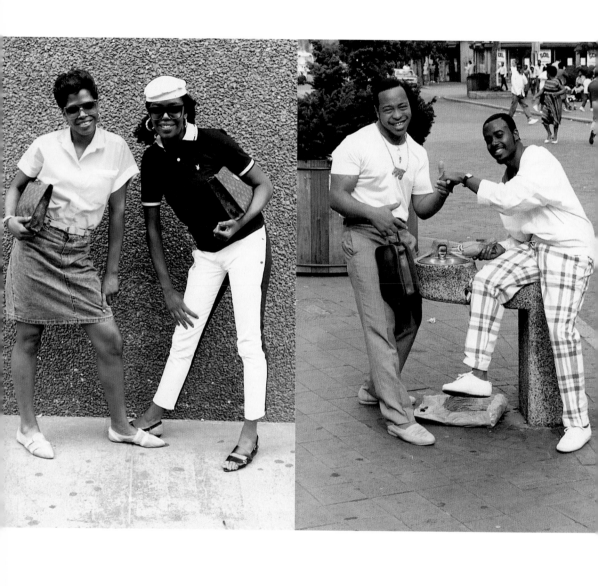

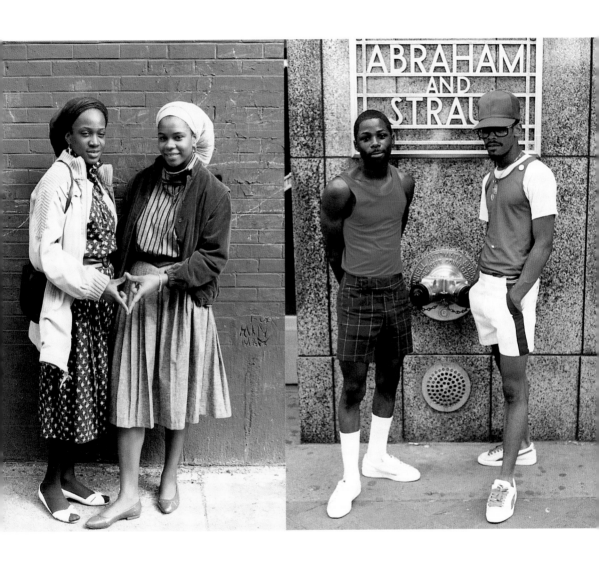

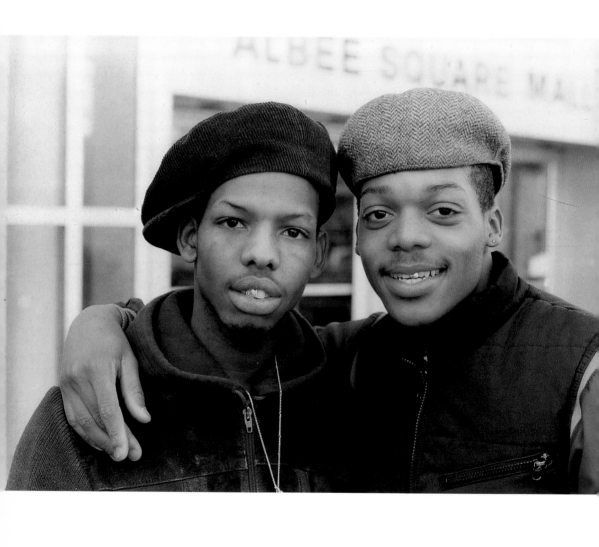

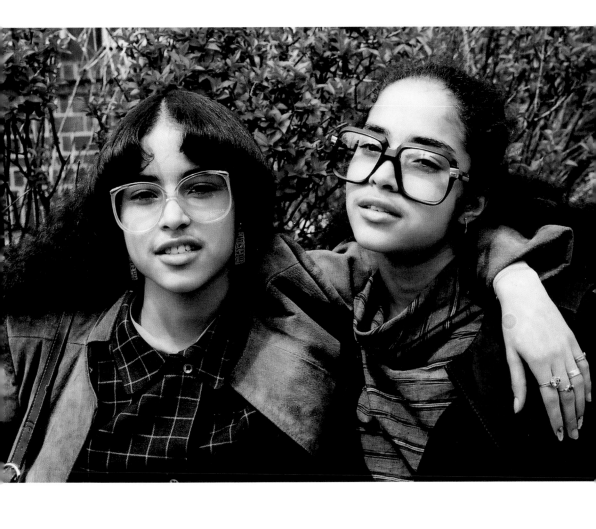

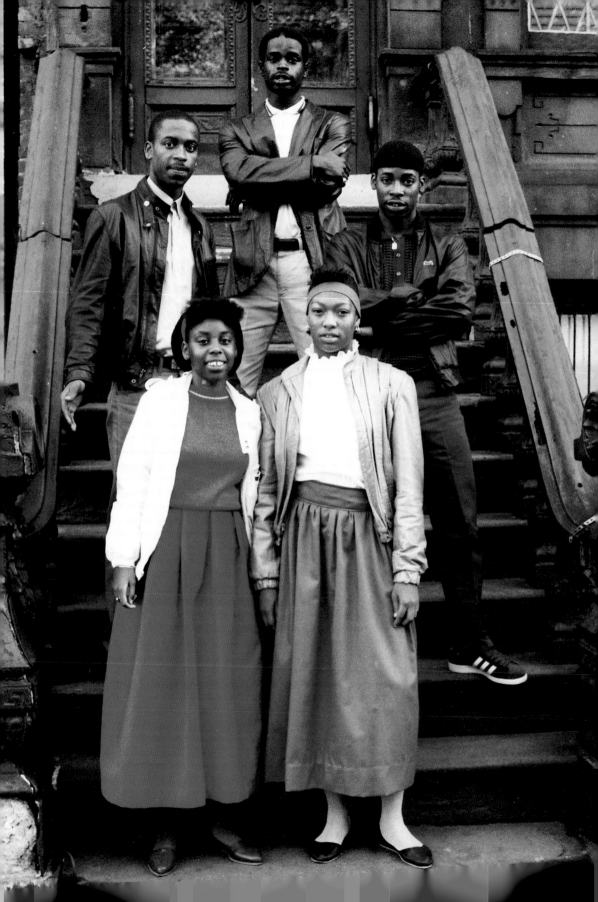

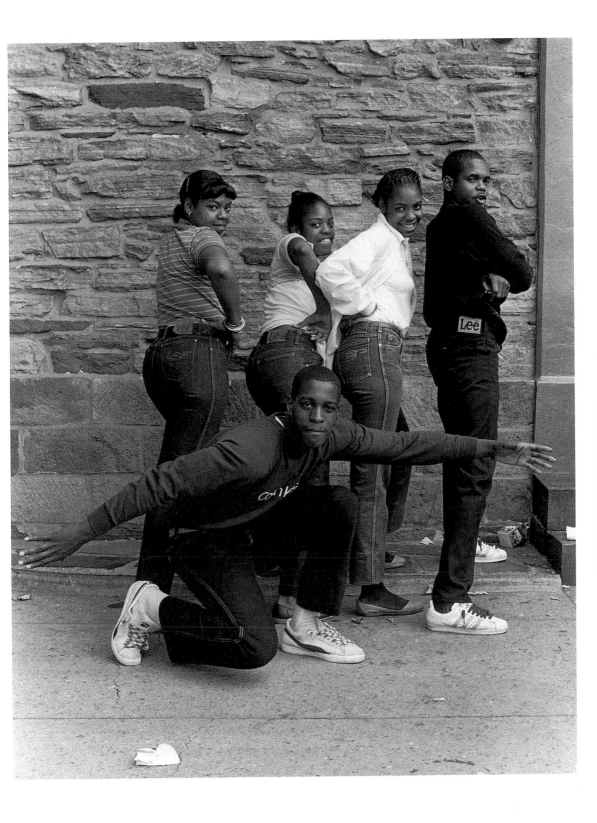

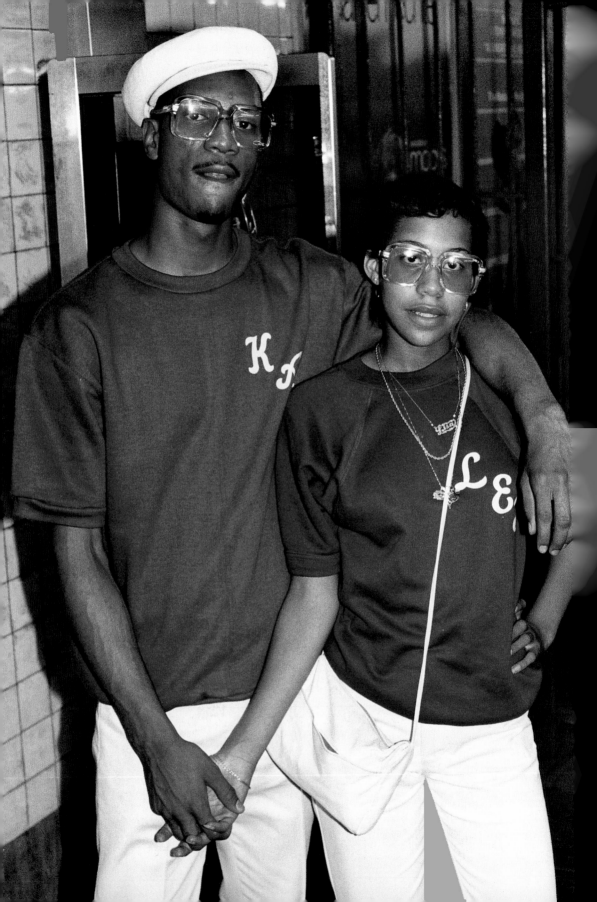

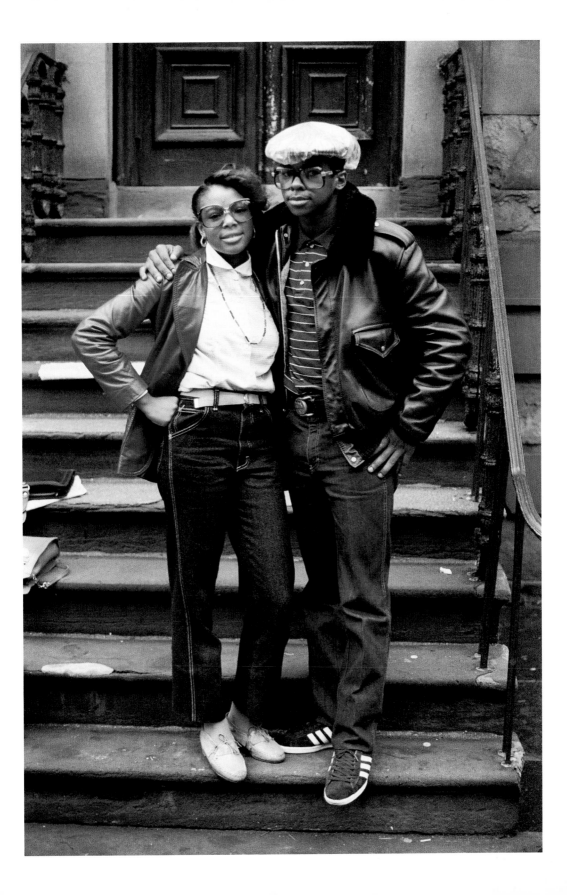

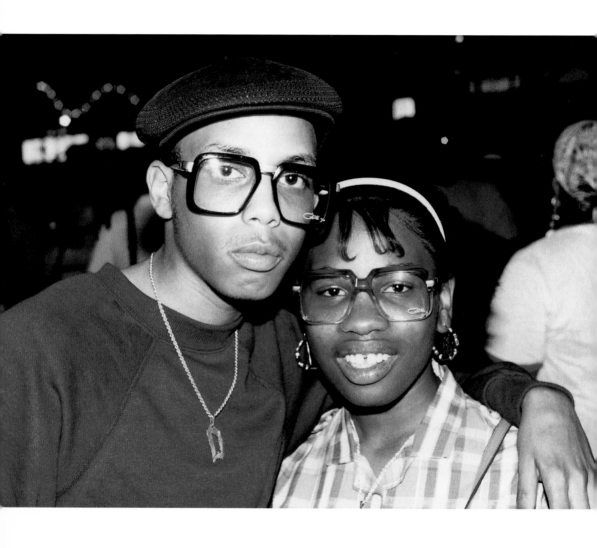

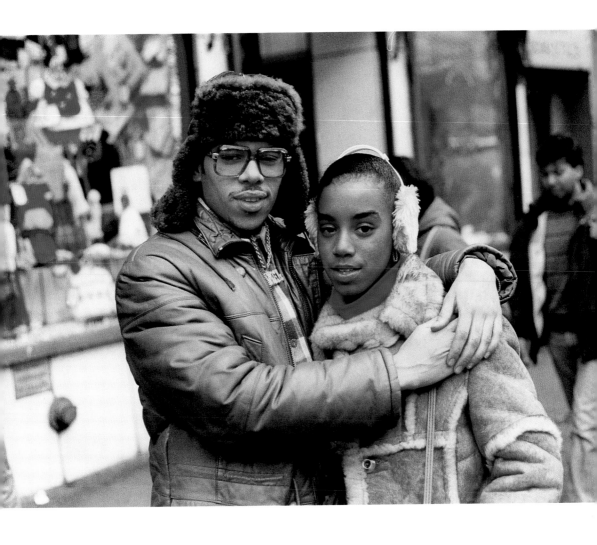

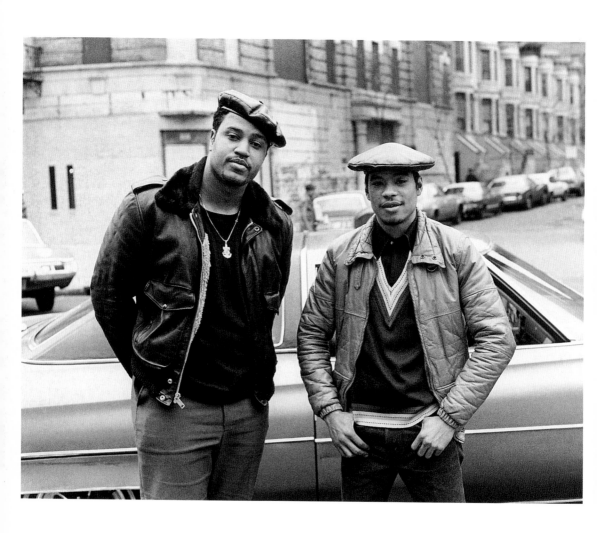

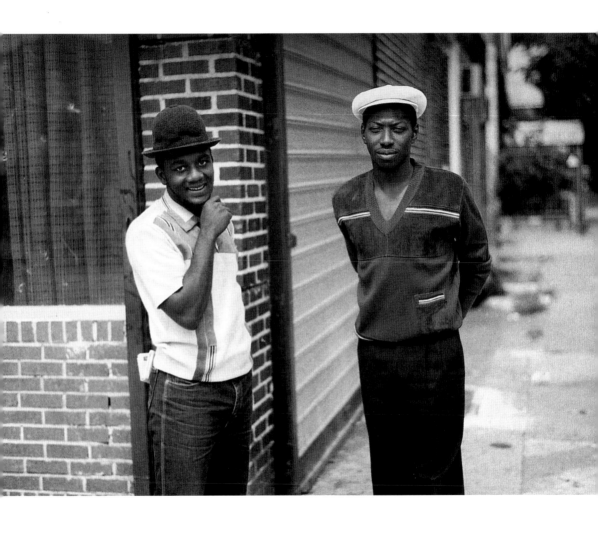

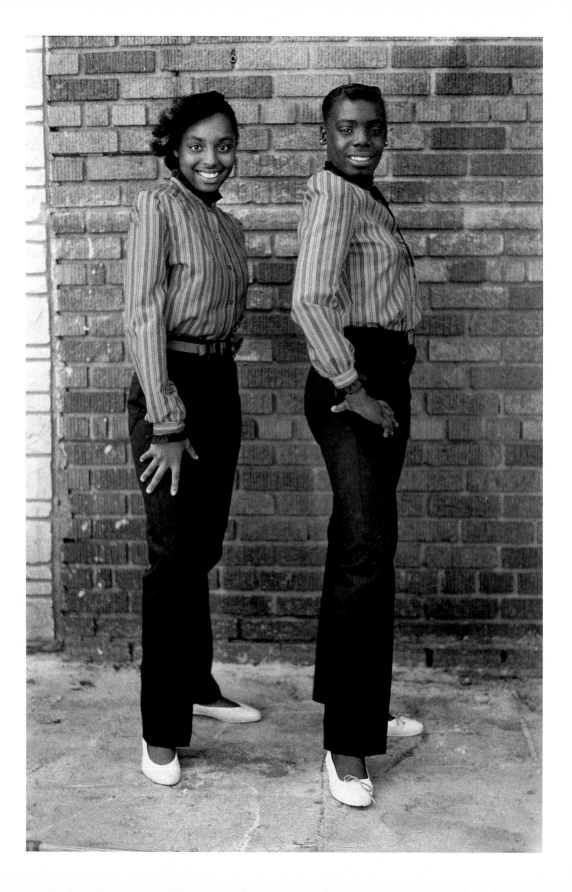

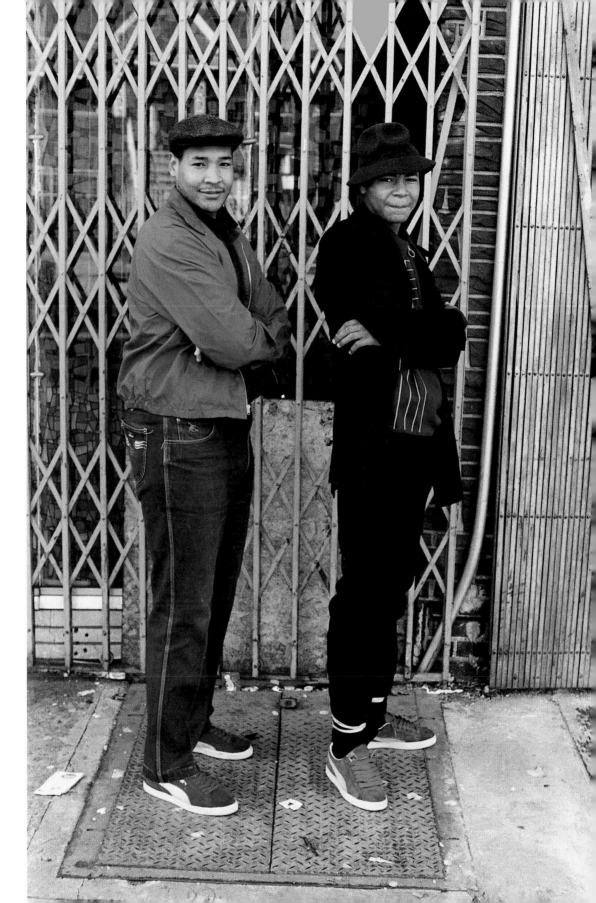

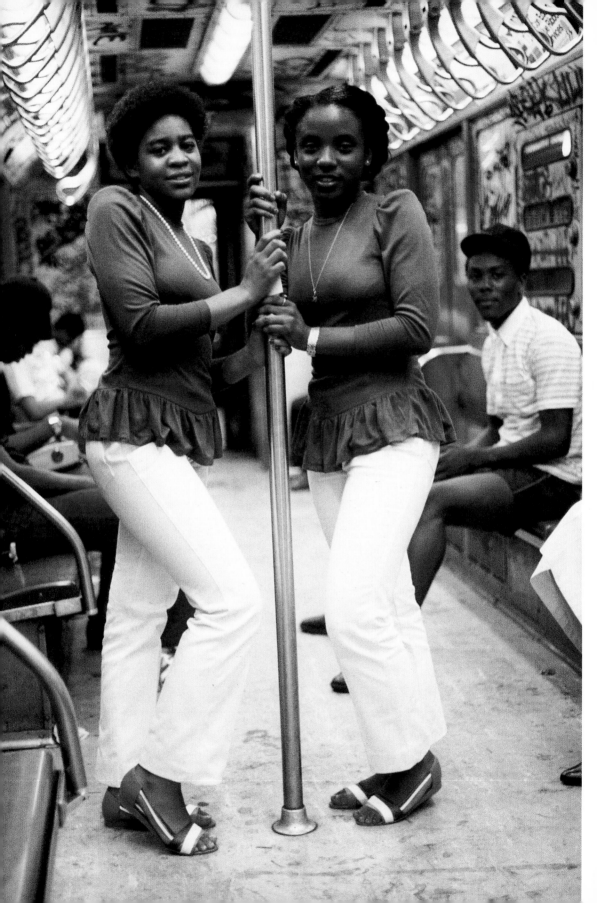

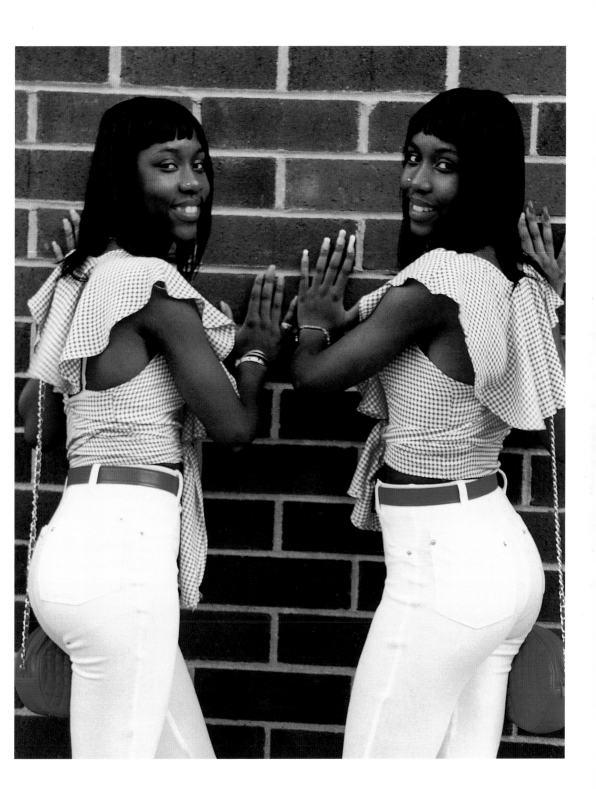

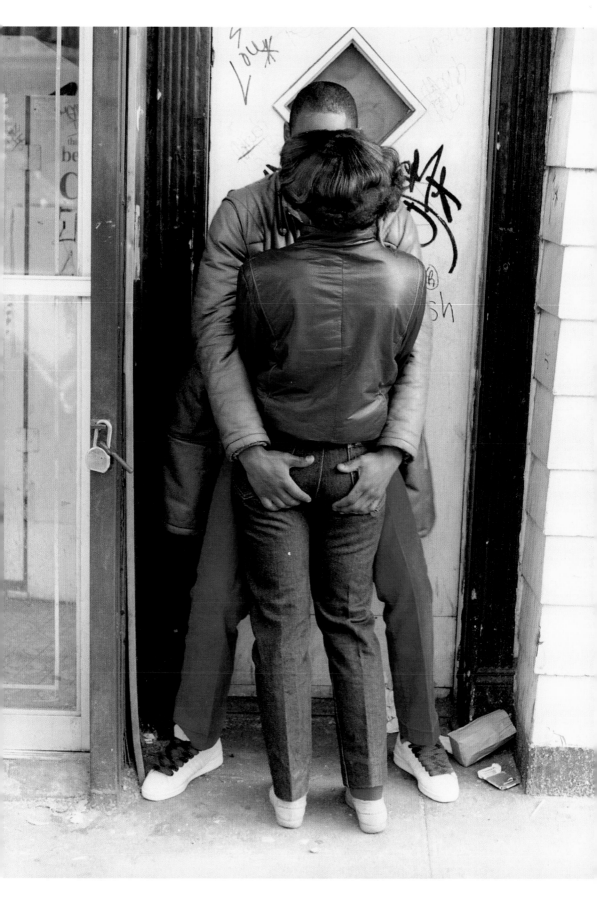

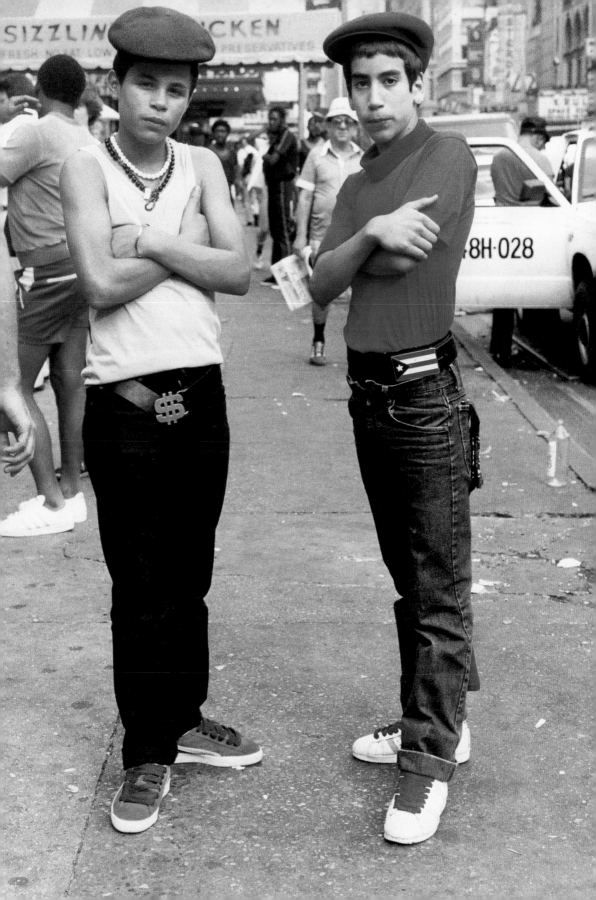

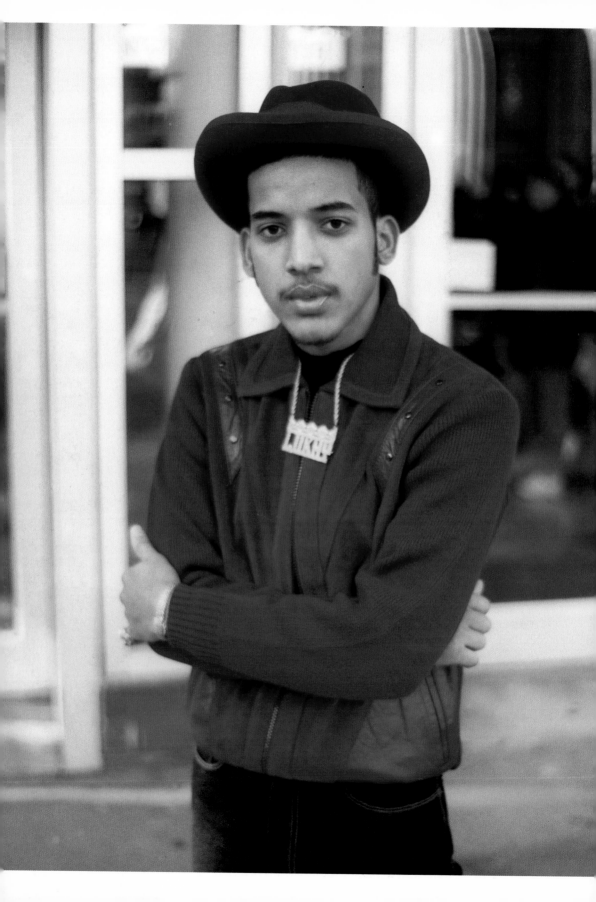

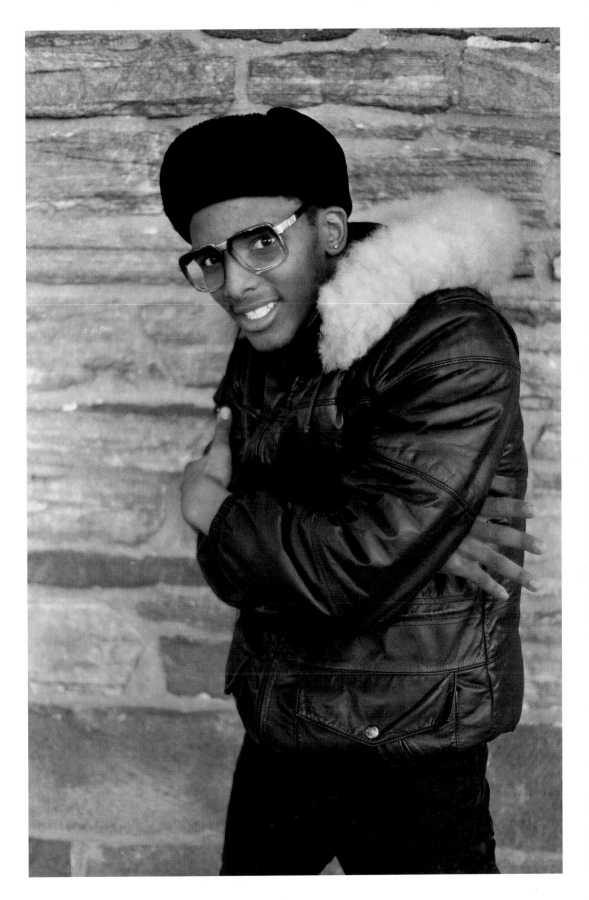

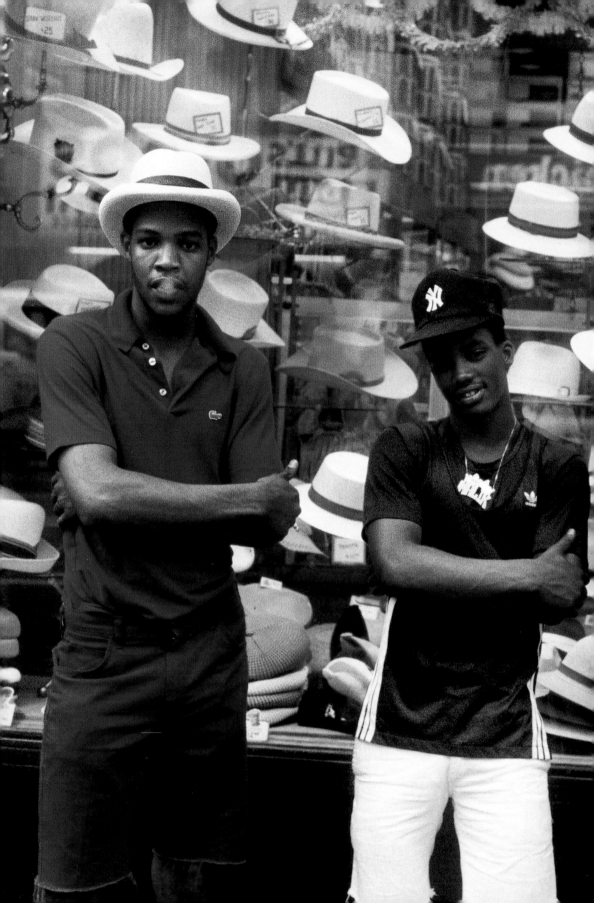

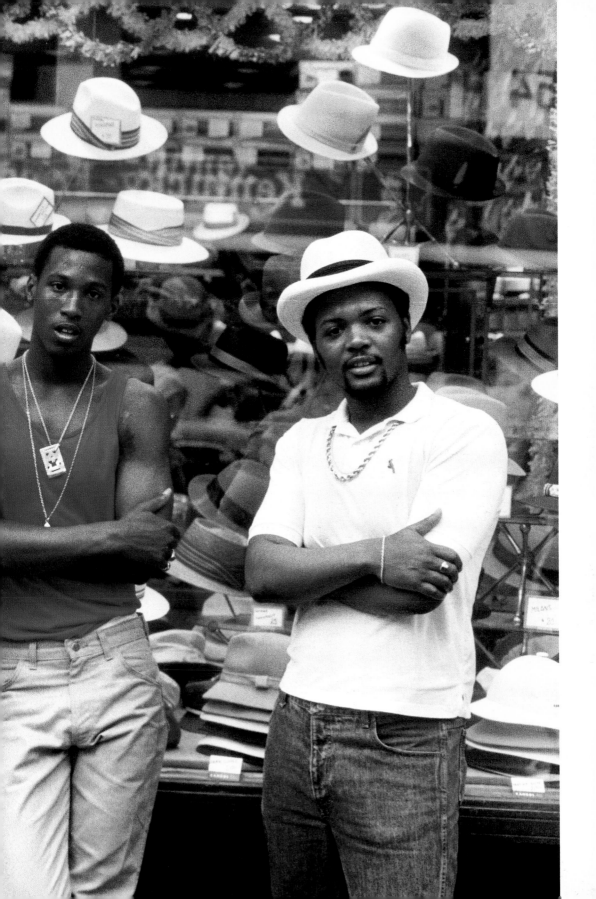

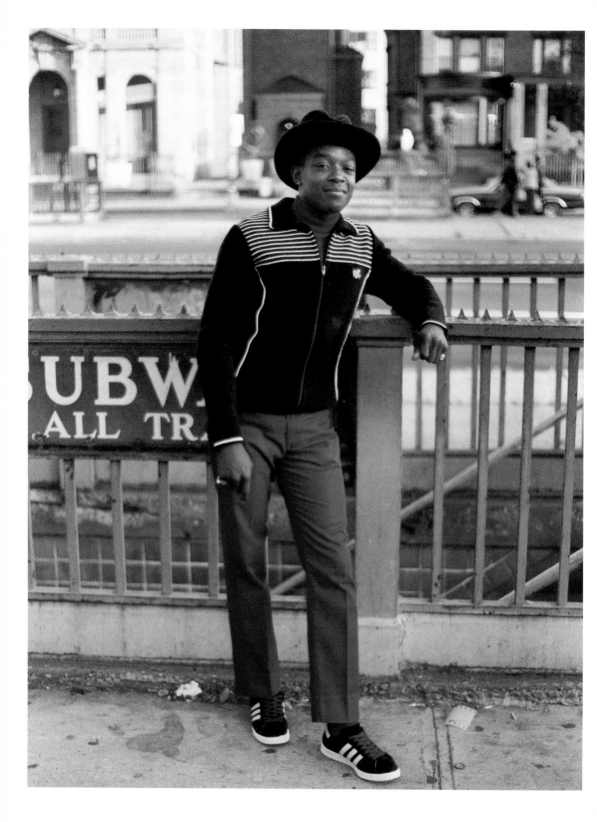

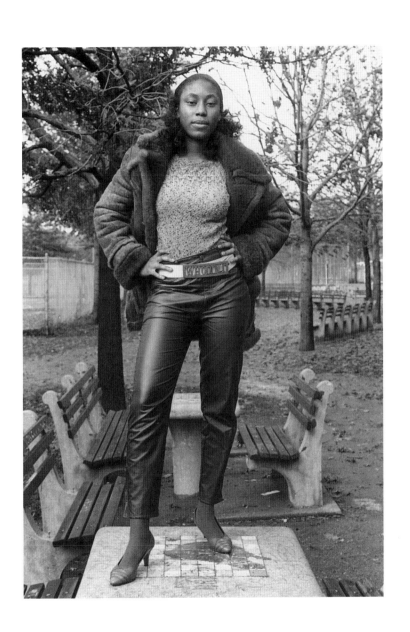

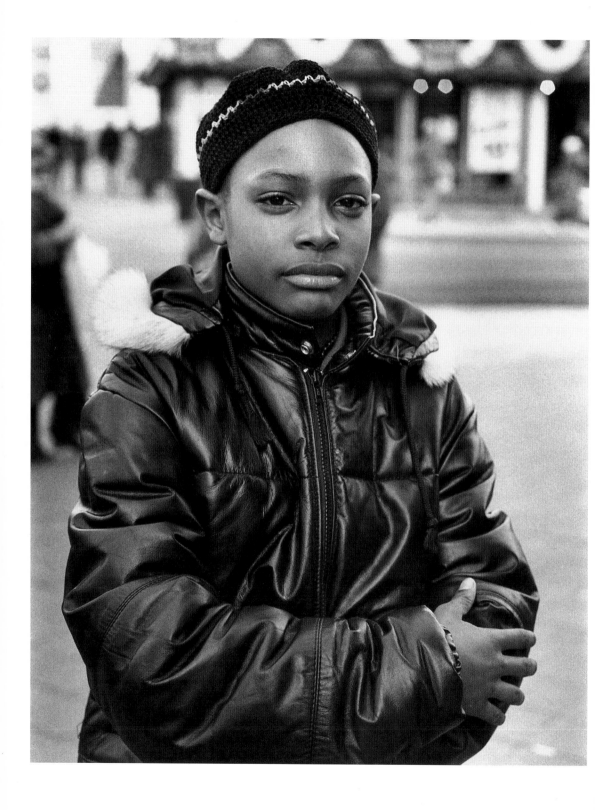

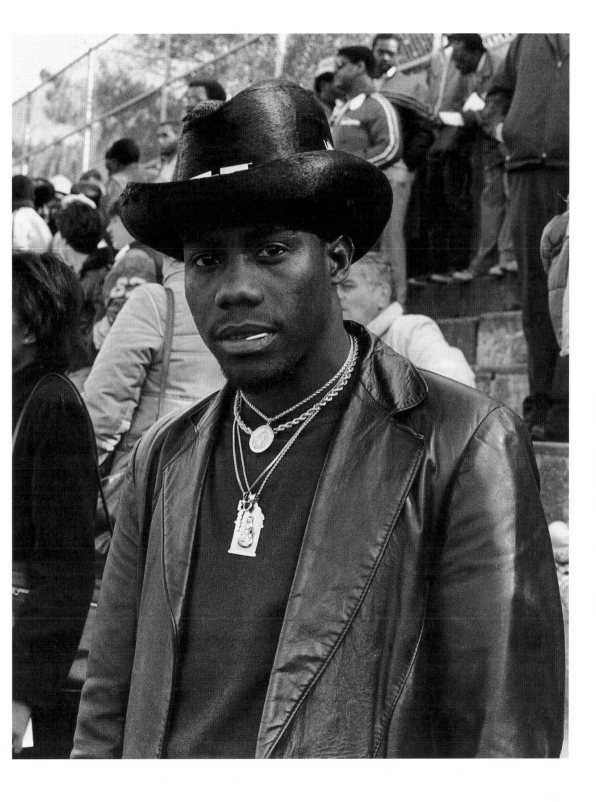

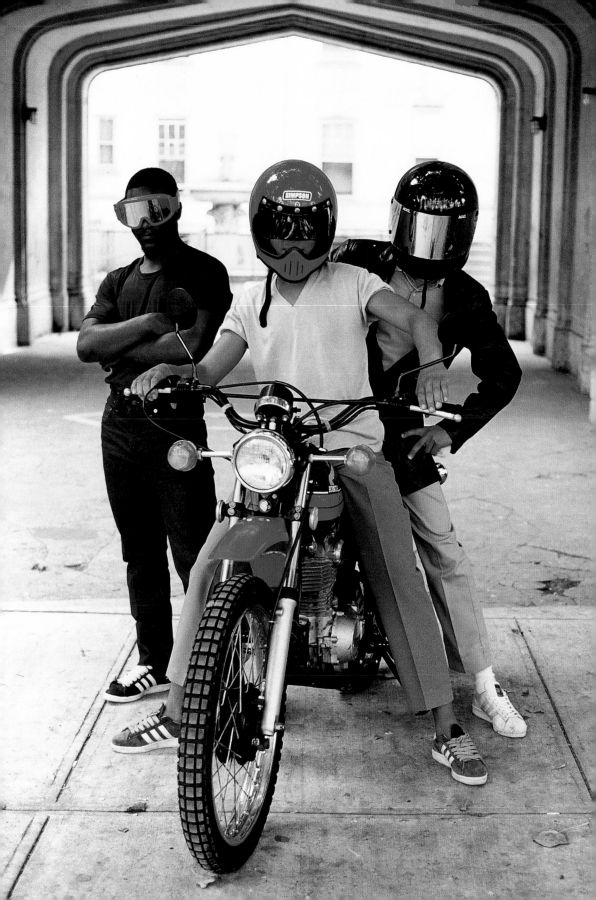

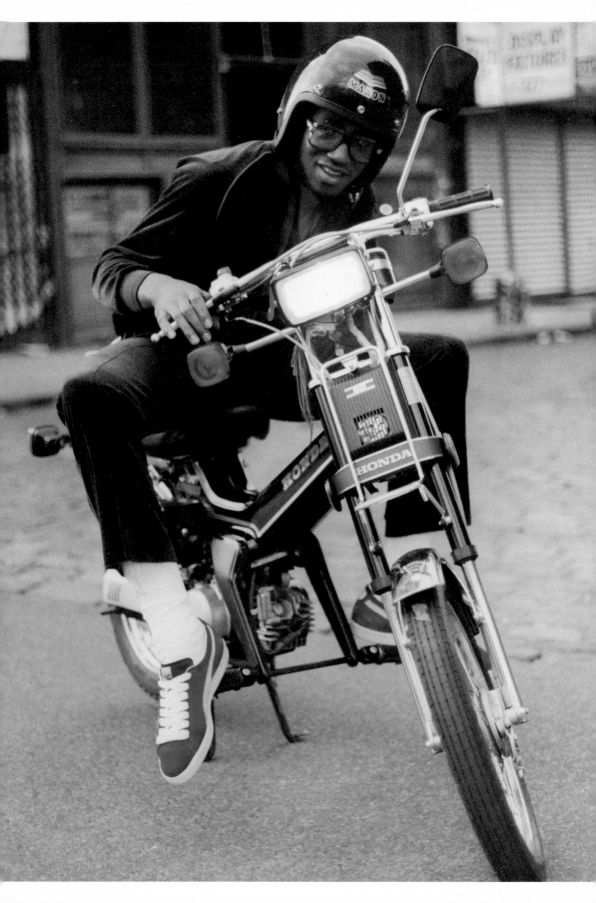

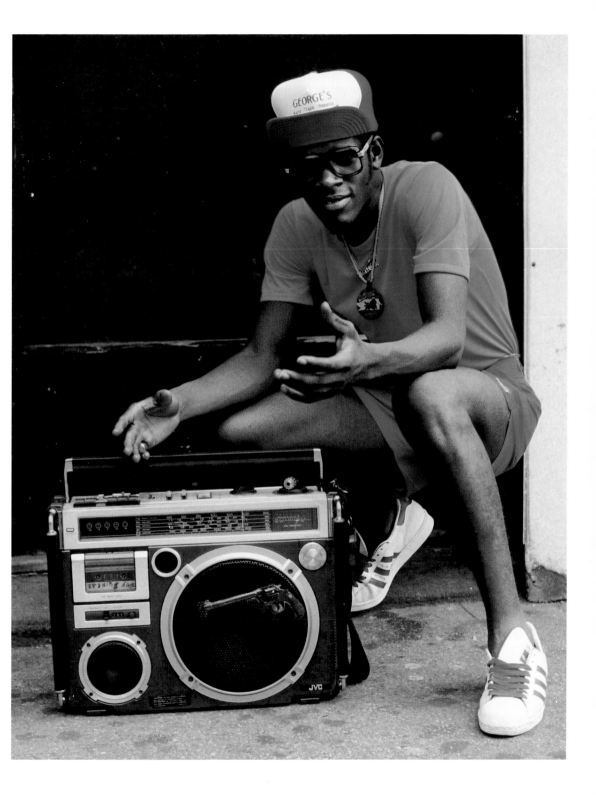

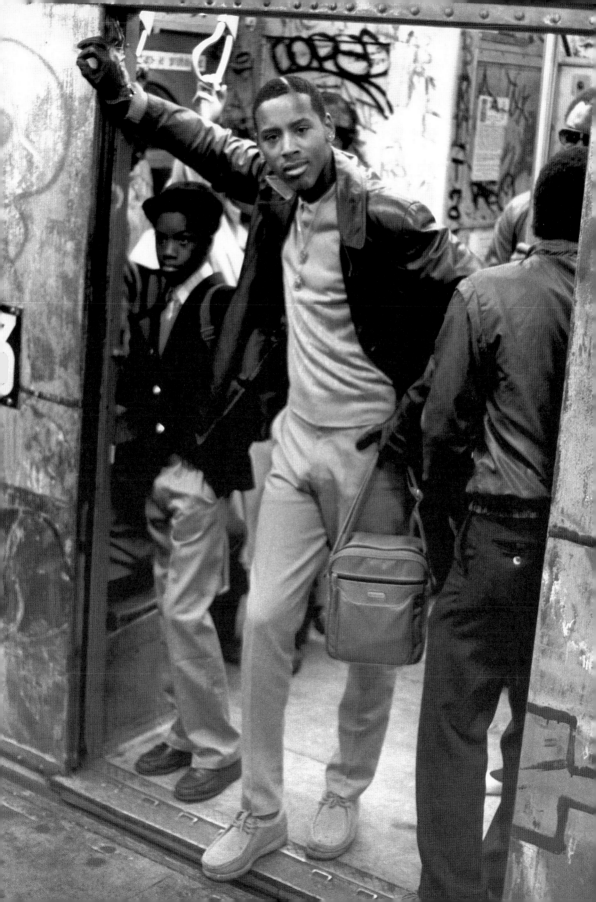

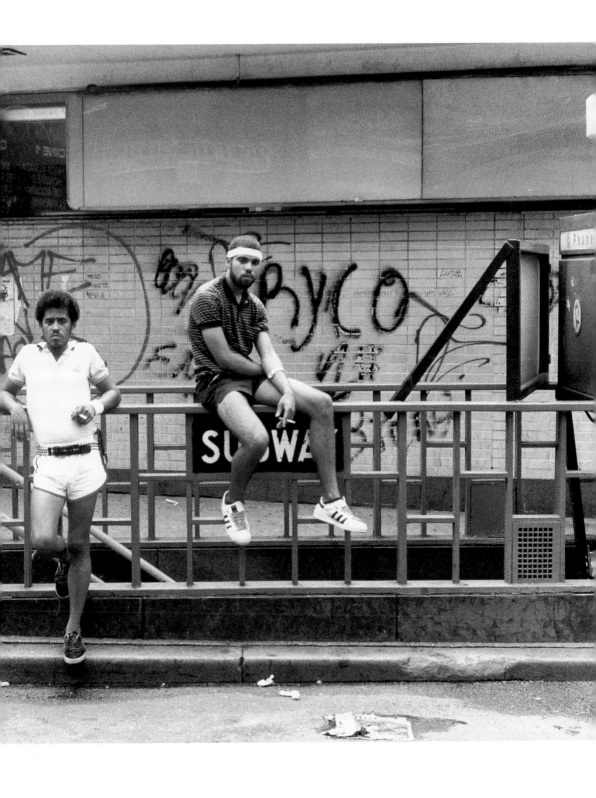

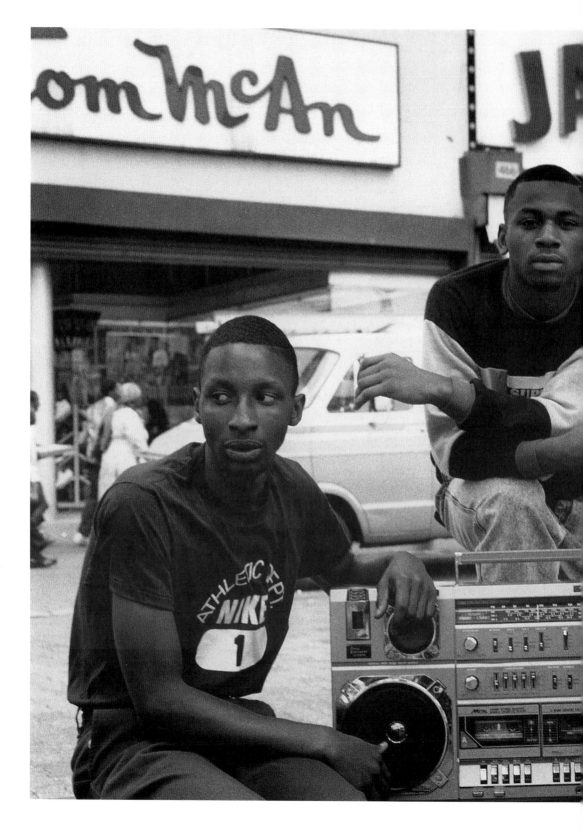

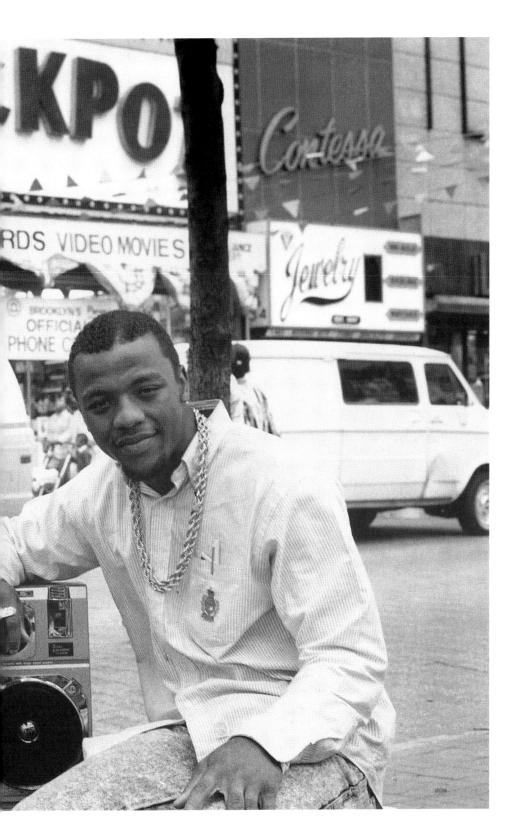

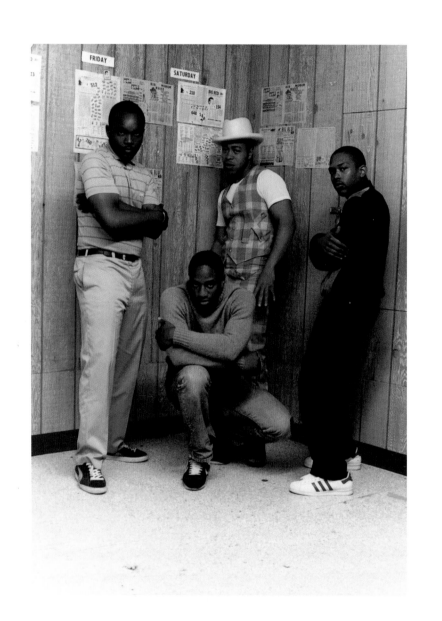

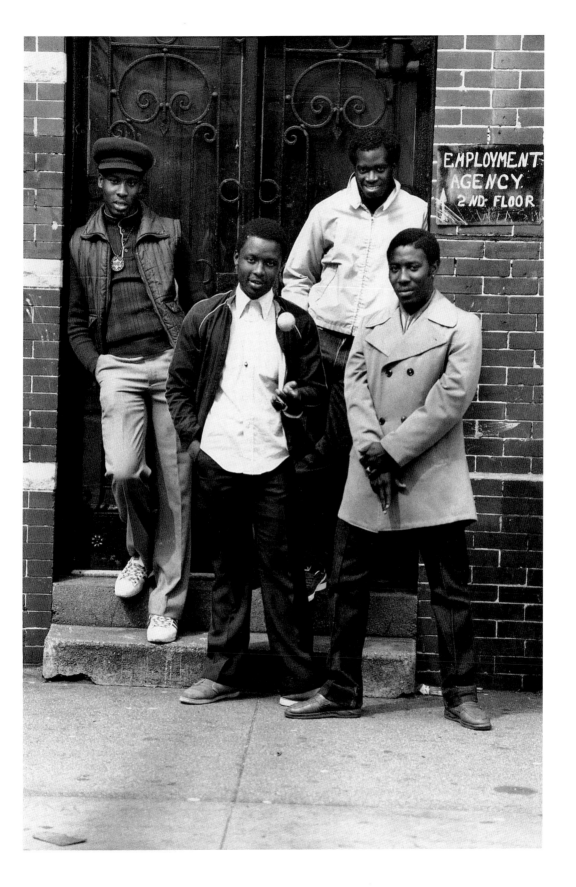

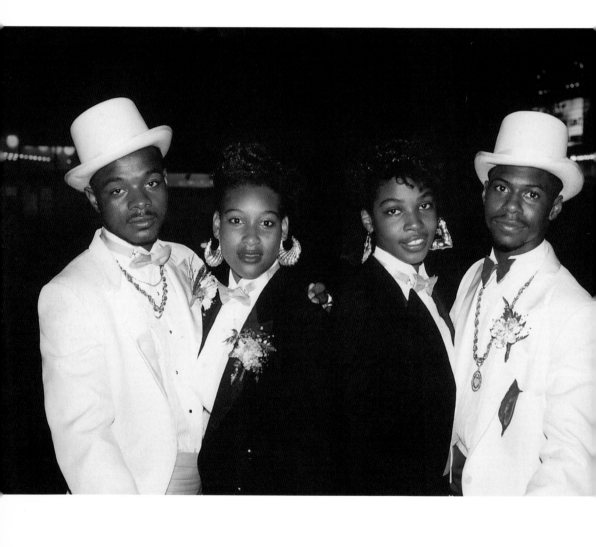

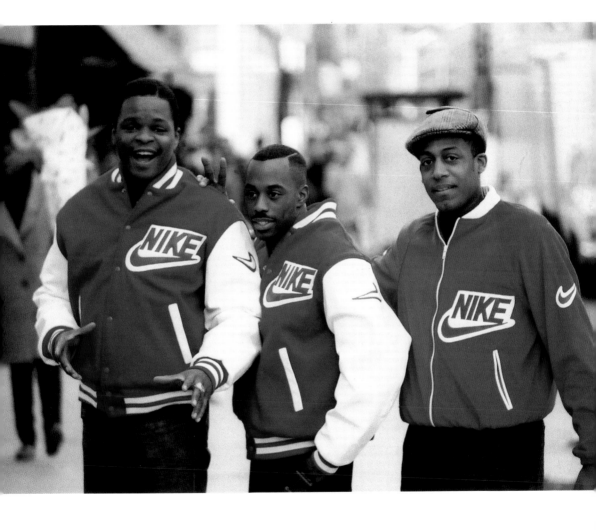

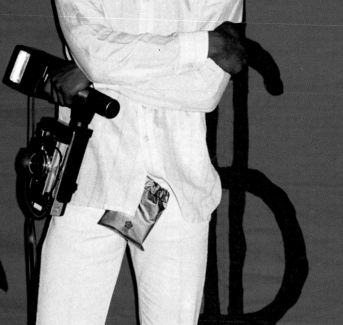

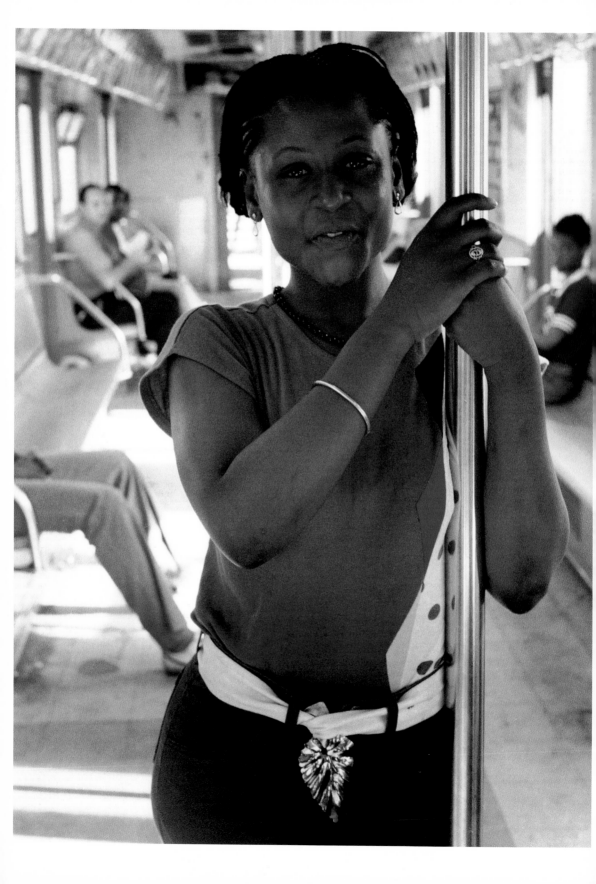

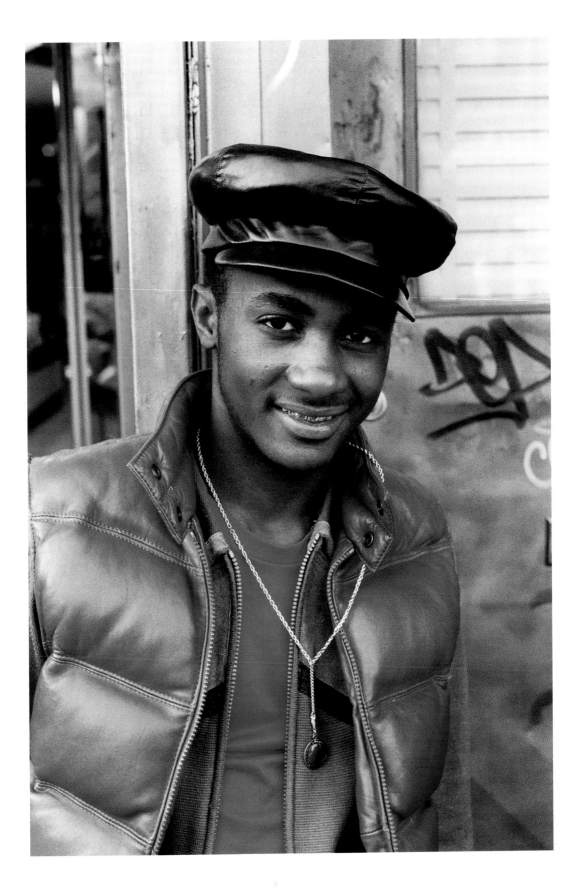

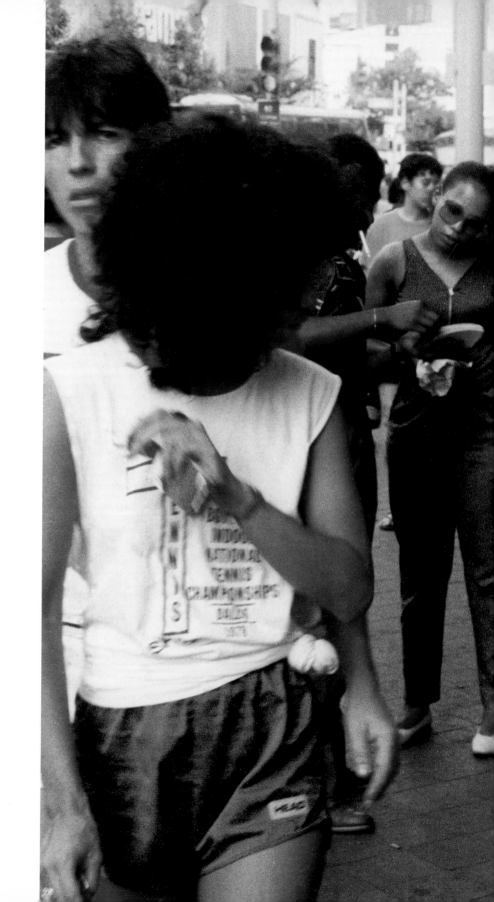

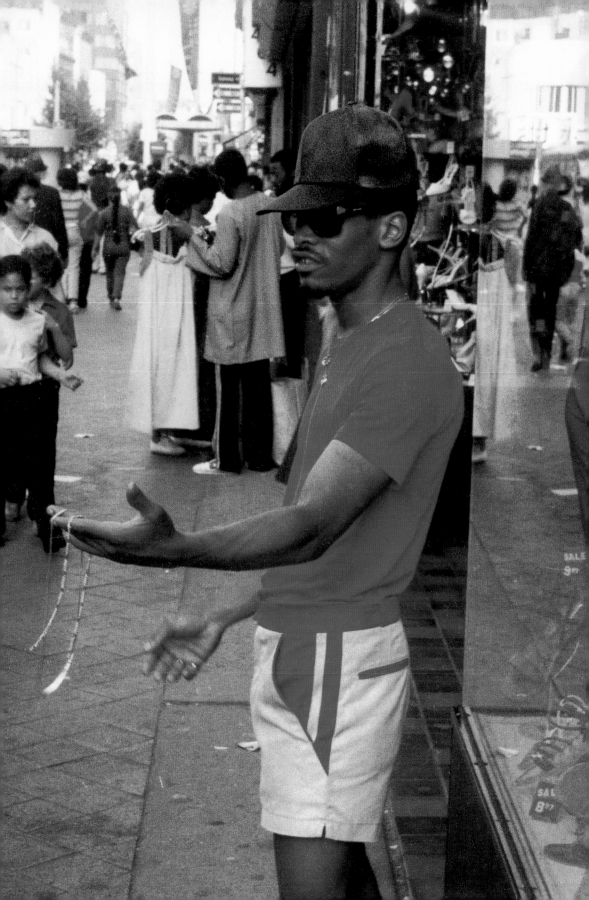

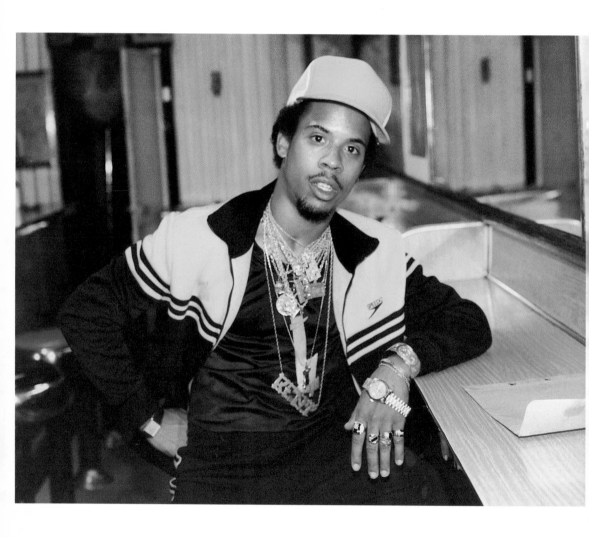

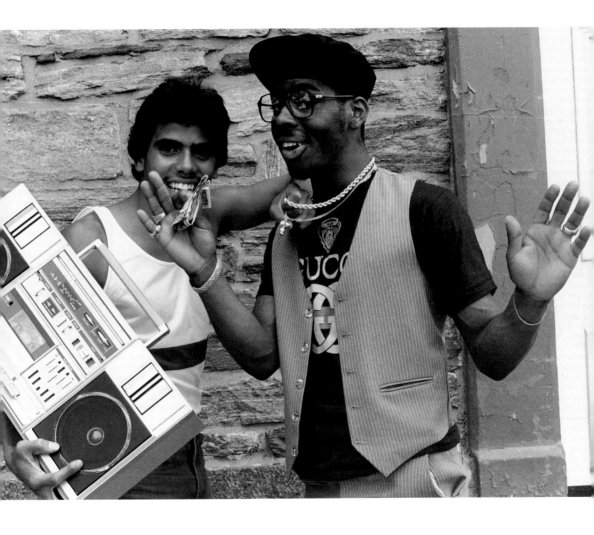

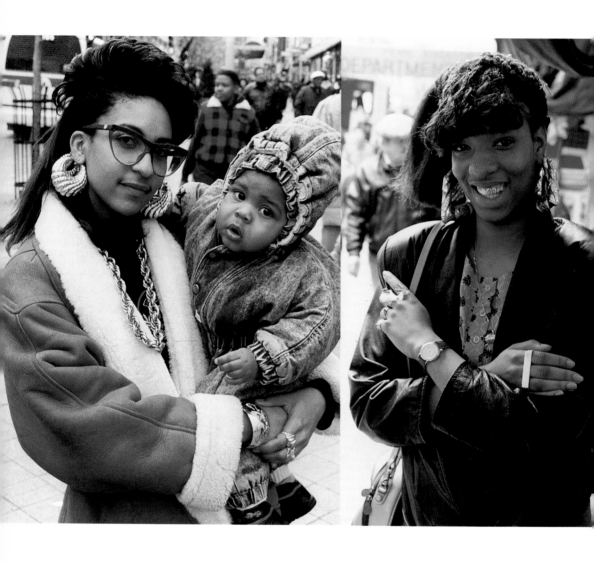

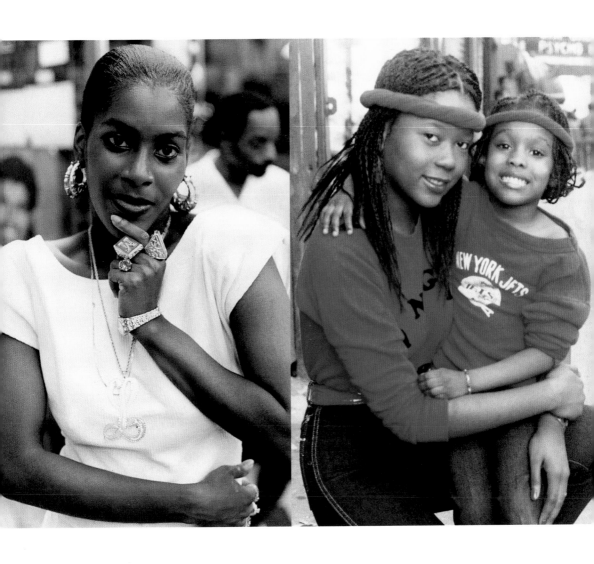

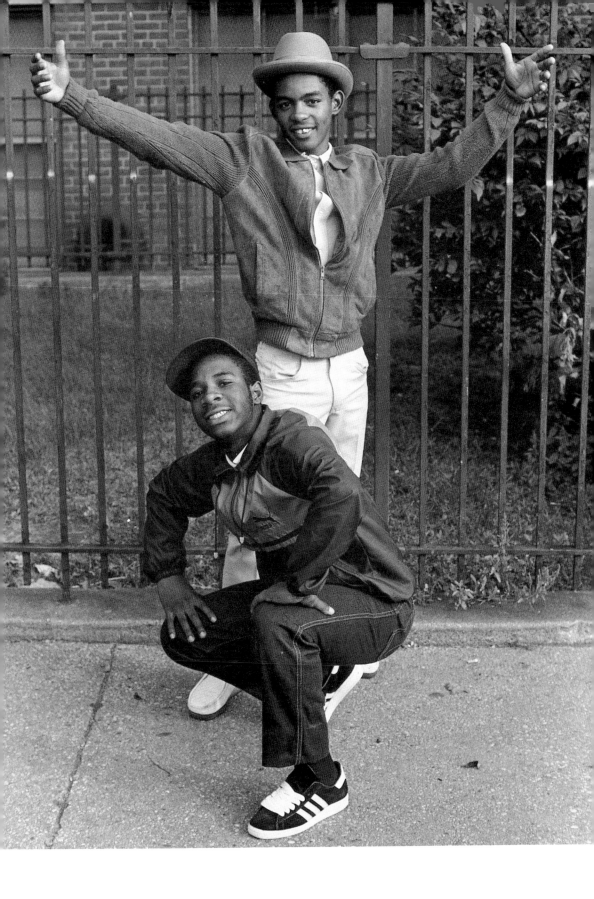

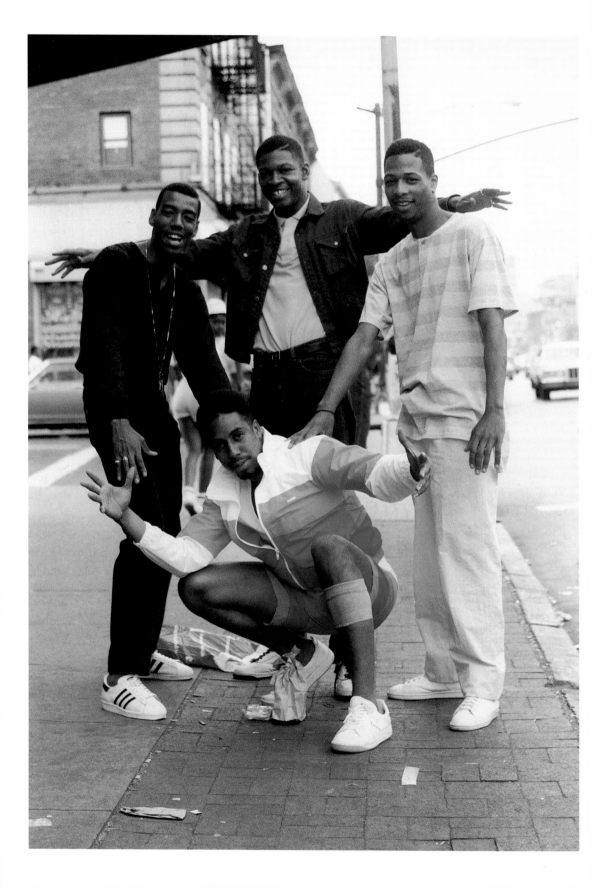

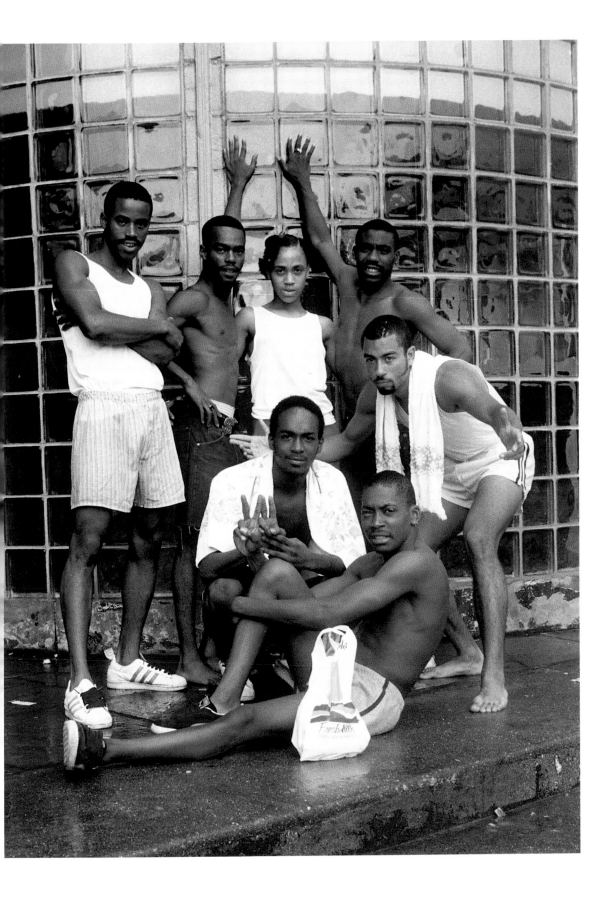

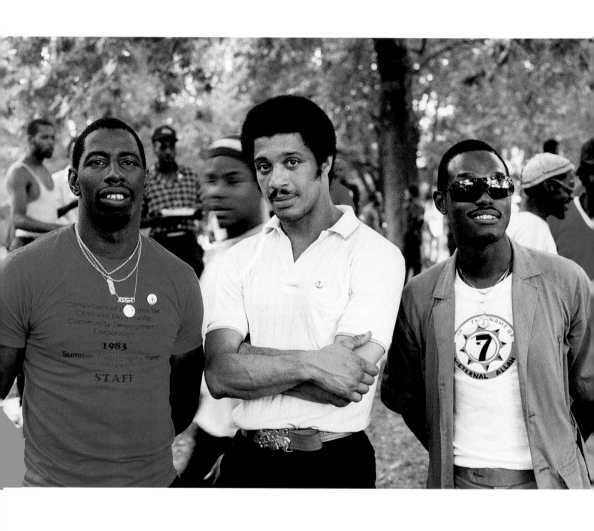

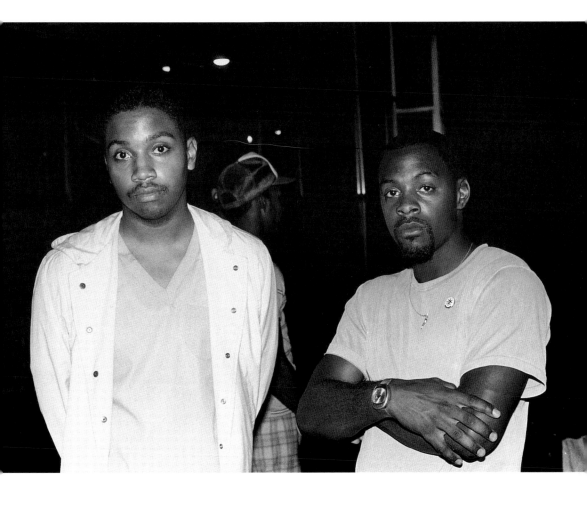

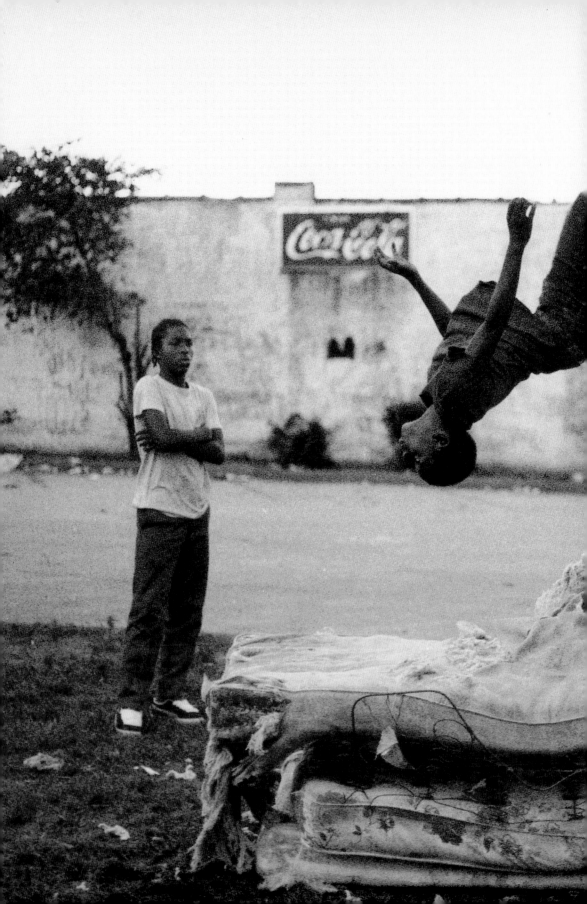

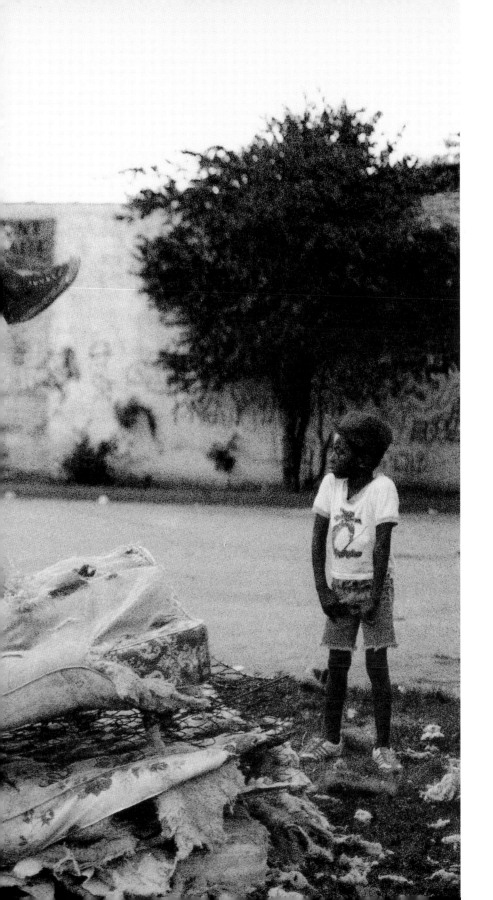

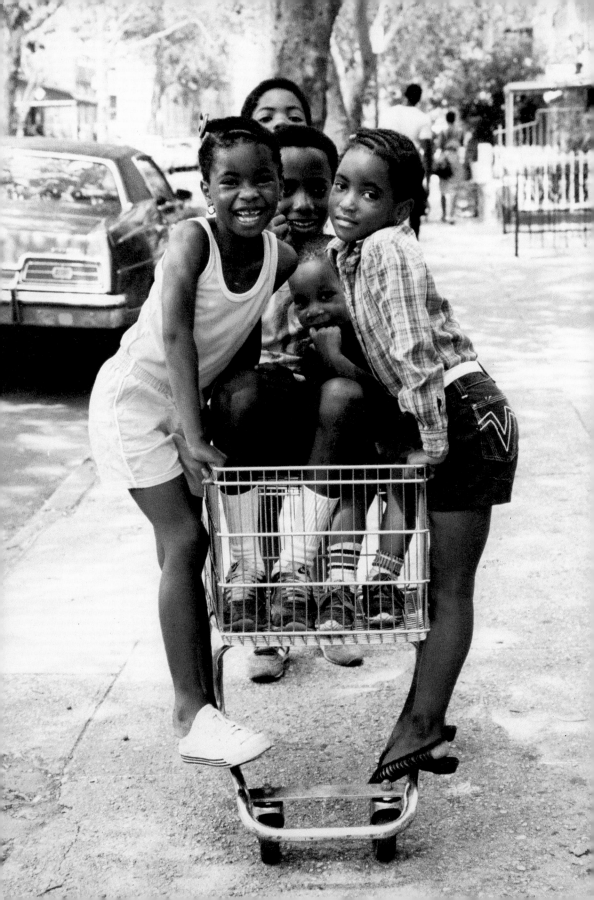

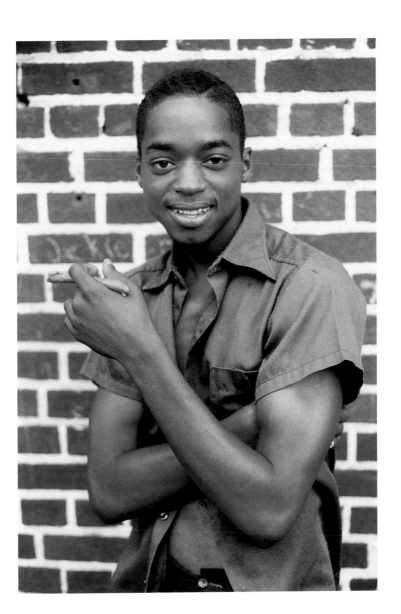

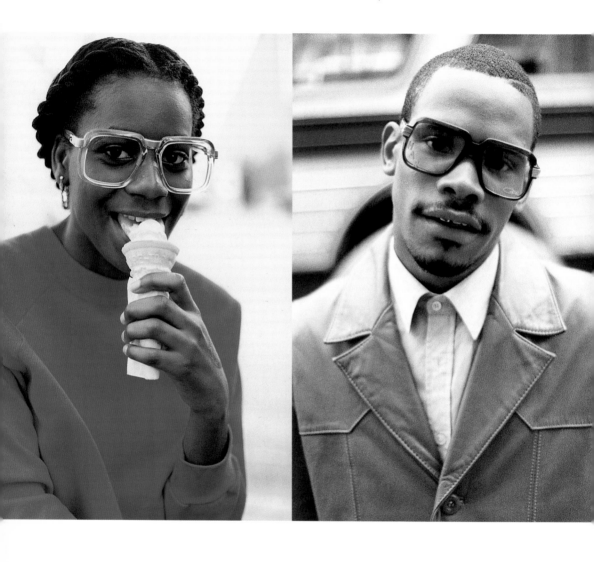

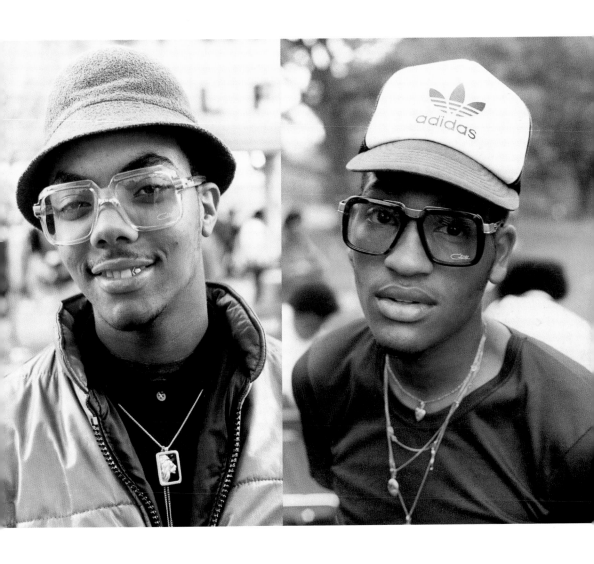

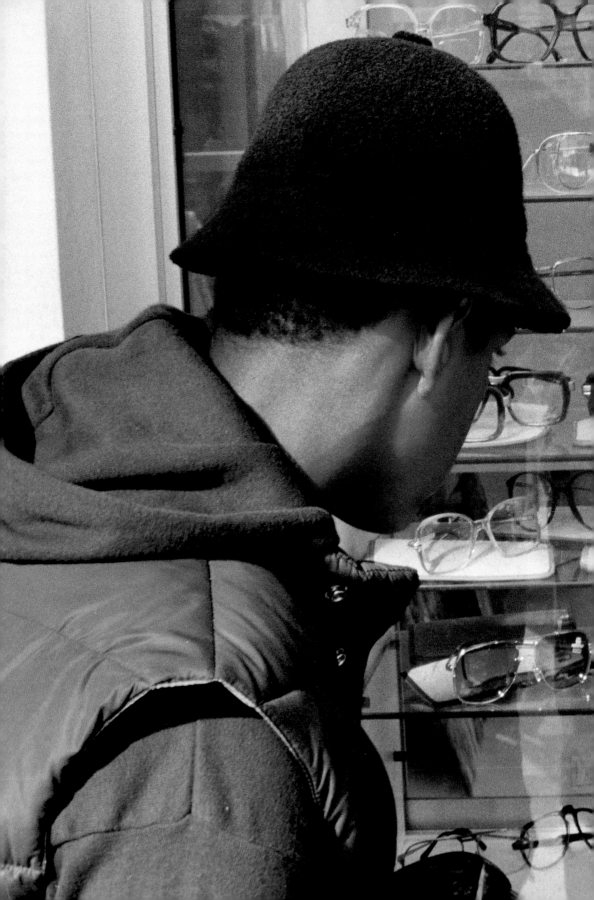

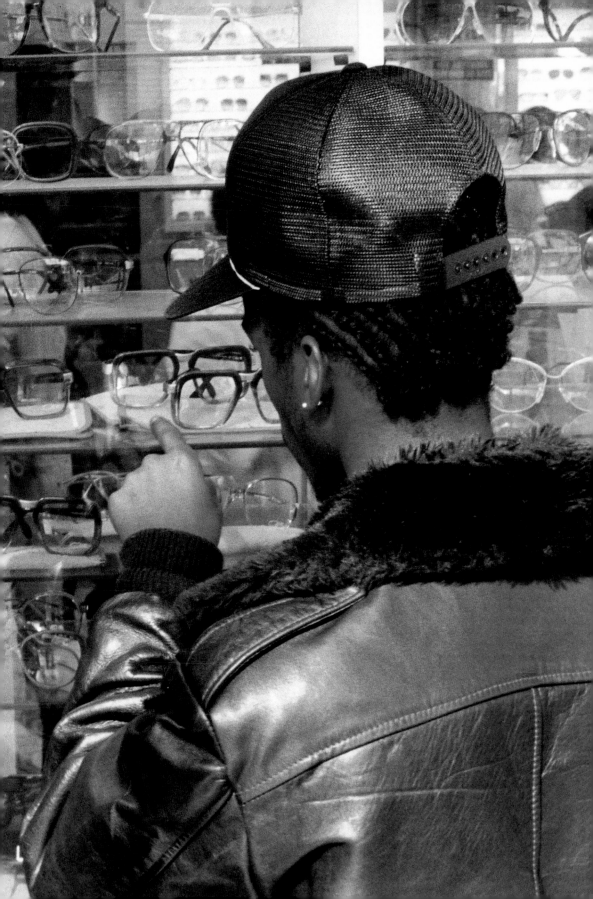

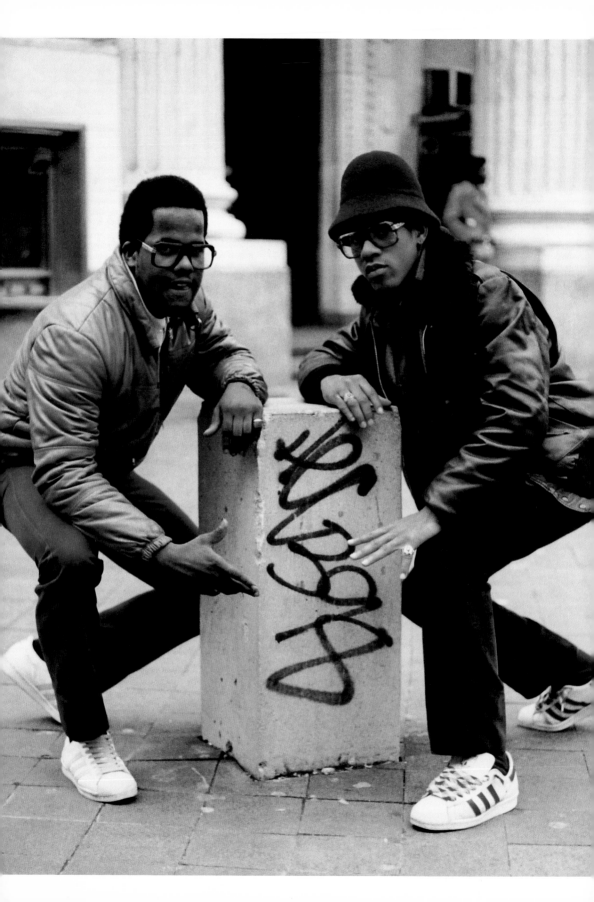

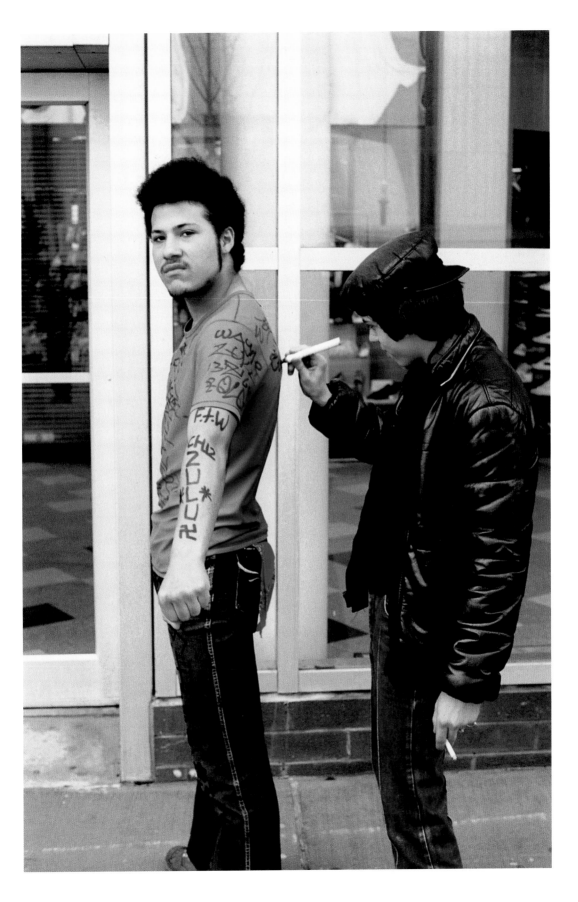

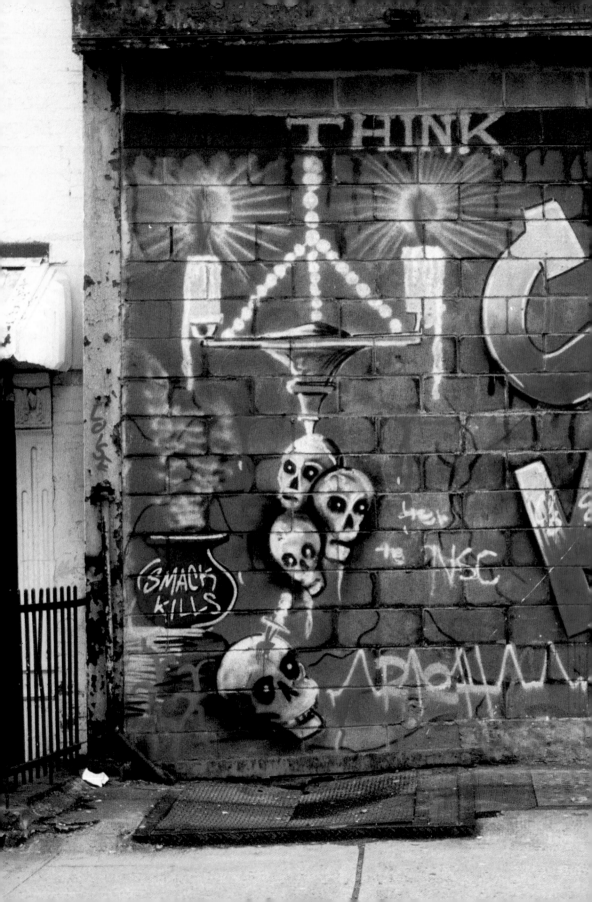

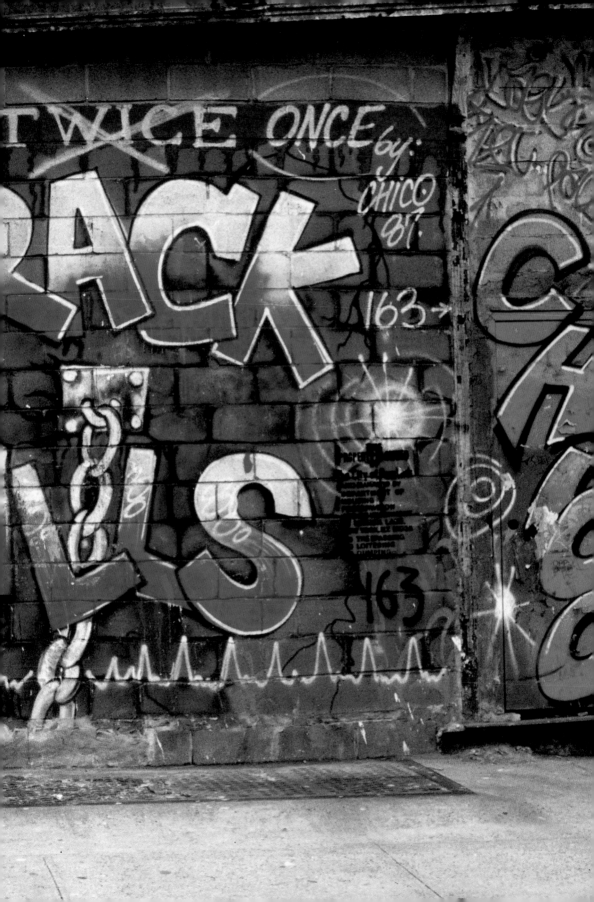

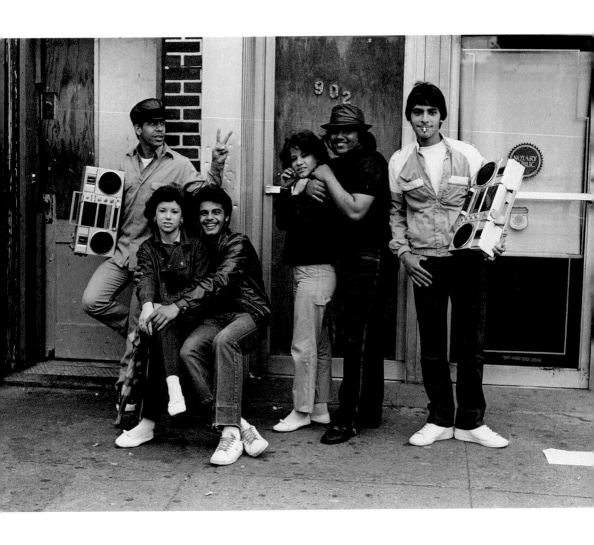

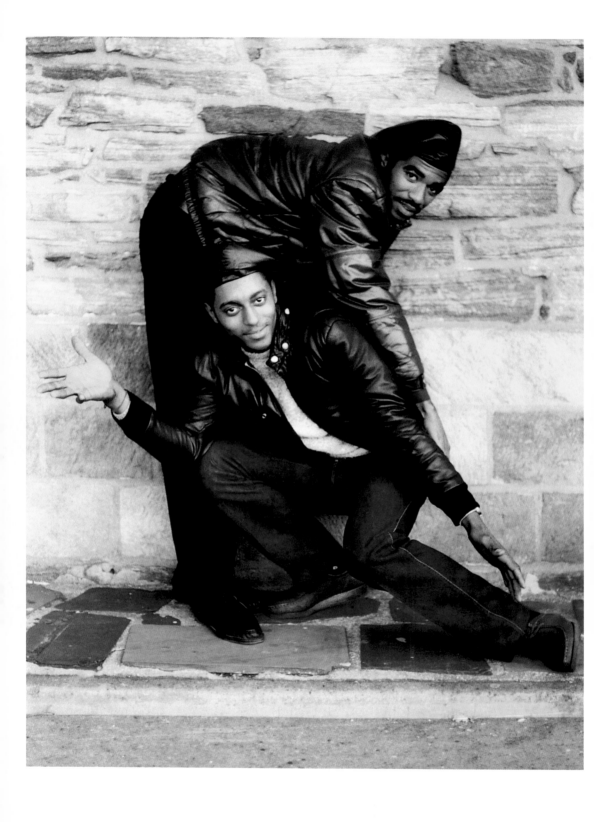

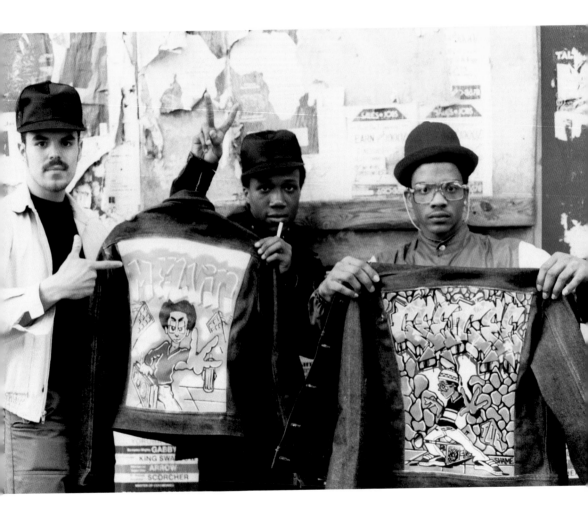

All the photographs included in **Back In The Days** were taken between **1980** and **1989**.

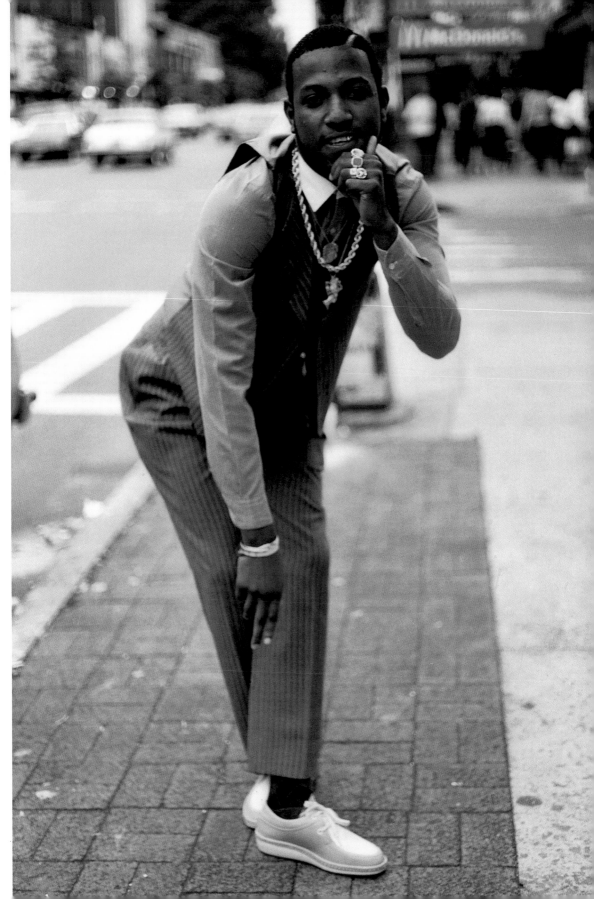

As a child growing up in Red Hook Projects in Brooklyn, New York during the turbulent 60s, my vision was shaped by images of the Vietnam War and the Civil Rights Movement. It seemed like every time I turned on the television, a program was being interrupted with a special announcement of another assassination. As a young child of nine years, I vividly remember watching "Lost in Space" when a news flash told us that Robert Kennedy had been killed.

History became my love. I spent hours in the library reading books about the social conditions of the world. Mike Wallace's program "Biographer" opened my eyes to the history of the world. I never missed an episode. I explored my father's *Playboy Magazines*. First I would check out the photography, then the interviews. These interviews were my introduction to the greats such as Malcolm X, Martin Luther King, and Jim Brown. Little did I know, my worldview was being formed.

One day my father came home with a coffee table book by Leonard Freed called *Black in White America*. I remember opening it up and seeing that it was an autographed copy. As I paged through the book I was captivated by the black-and-white images. Freed eloquently displayed the contrast between the lives of Blacks and Whites, both here in New York as well as in the segregated South. I had never been South before, and this book allowed me to take my first visual journey there. I would study the pictures so often and for so long that the pages eventually came loose. As time passed, the book was reduced to a raggedy collection of photographs, but it there is no doubt looking back that it was the spark which made me aspire to become a photographer.

Around this time, my family relocated to Flatbush, Brooklyn and there my world changed. In Red Hook, I never knew about gangs, but after moving I saw them first hand in Brooklyn's tri-section area of Flatbush, Crown Heights, and Brownsville. Flatbush and Crown Heights was the home of the Jolly Stompers, Pure Hells, and the Crowd Pleasers. In Brownsville the Unknown Riders and the Tomohawks reigned.

I became good friends with a brother named Winston who was strong, confident, and very swift with his hands. He told me that his cousin, Corneal, who went by the name "Sundance," had taught him everything he knew and was the warlord for the Bad Ass Stompers (a division of the Jolly Stompers). As time passed, he invited me to travel with him to Sundance's home. I was down.

We went to Rutland Plaza, which was located on 92nd Street and Rutland Road in East Flatbush. This was the first time I would meet a member of a top gang. Sundance was a smooth brother about 5' 8" with a medium build (I expected someone a lot bigger). He had a very neat and organized room. I'll never forget the music that was playing—a Kool and the Gang album, "Light of World's." The song that was on was "Rhyme Time People." While listening to the music he handed us each photo albums. As I opened the first album up, I was blown away with what I saw. There were powerful photos of the Jolly Stompers standing tall and looking strong, with oiled beaver hats, tailor made pants, "Playboy" shoes, mockneck sweaters, and so much more. The music continued to flow with each picture. I left there feeling a strong sense of purpose.

As soon as I got home, I snatched up my mother's 126 Kodak Instamatic camera and started my photographic journey. I started shooting my partners in junior high school. It was lovely. I would drop off a roll of film at the corner drugstore and it would usually take about three days for the results. The wait was well worth it. I would then return to school and give my partners some of the photos. It started to get a bit expensive, so we would take two collections, one for the Old English and the other for the film. It worked out fine.

In the mid-70s, one of the greatest television movies on was the mini-series "Roots." This powerful epic showing our capture, voyage from Africa to America, and our enslavement had a profound impact on everyone. Once "Roots" aired, we started to look at ourselves differently. Righteousness prevailed and "Wake Up Everybody" and "Love Is The Message" became the two most popular songs of that era.

As time went on, so did I, and I started rolling with a 110 Kodak Instamatic Camera which allowed me to get better quality and wider images. I returned to Red Hook in the summer of 1977 and it was off the hook. Rhyming had started to get cut into the mixing and a brother by the name of "Moose," along with the Disco Enforcers, took music to a whole new level. Unfortunately, I got distracted by this new

phenomenon, and having to make a choice on spending my money on film or good times, I chose the later.

The day of my seventeenth birthday, July 13, 1977 New York City suffered an electrical blackout. I decided to sit back and nurse a couple of quarts of Old English. With so many stores getting looted, it seemed that everyone had at least five pairs of Pumas and Adidas. In the days and the weeks that followed, fashion made yet another turn. Cats started wearing gold chains, fly glasses, and Panama Hats. Some would even change clothes two or three times a day, something you never saw prior to that infamous July.

A new offshoot of gangs started. "The Crew" was much more than a gang and consisted of about five to twenty individuals, all from the same neighborhood, and all dressed a lot alike. Most were the younger brothers of the original gang members. They went by the names like the Dowops, the Puma Boys, the Cats, and the Godfathers. When battles ensued they would usually take place at a block party or house party. Gunshots became as normal as rapping. By this time, I had picked up my first 35mm Cannon AEI. I felt the need to photograph this new lifestyle, having missed the gangs of the 70s. I didn't want to miss the "resurrection."

I felt the need for self-discipline so I learned to play chess and began to read books on sociology and philosophy in order to better reach the people I wanted to photograph. I reflected on the television show, "Kung Fu" with David Carradine, who played a character named Caine, an Eastern trained Kung Fu fighter. In the show, Caine returns to America after studying in China and is confronted with many obstacles and moral conflicts. One of the greatest lessons I learned from this character was the power of humility and discipline. I watched Gil Noble's, "Like It Is" and "The McCleary Report" for additional insight. These programs helped me develop journalistic skills and the art of professionalism. I felt ready to take on the 80s.

Ronald Reagan was president and the consciousness of young people began to change. In spite of greater and greater violence in the streets, the music started to drop science. I loaded my camera up everyday with TriX 400 or Fuji 400 film. During the weekdays I would spend most of my time throughout Brooklyn, and on the weekends, Time Square, Delancey Street, Jamaica Avenue, and sometimes Staten Island. My mission was simple. Travel throughout the city and capture the beauty and true essence of a people, starting with the teenagers.

Most of my partners' brothers were in their senior year of high school enjoying the foundation that we had laid for them. I had no problem photographing them and their crews. Guns were now readily available and most of them had one or two. It was my desire to point them in the right direction. They all gave me respect and I would sit and vibe with them, give them a few dollars, and try and turn them on to chess, jazz, and orange juice.

With the 80s came crack and AIDS. The 40 ounces of malt liquor, the sweet tasting Cisco (better known as liquid crack) and an entire generation were in serious trouble. I felt like Noah, warning of troubling times ahead. Everyone assured me that they'd be alright. As I photographed them, a feeling would come over me that it could be the last time I would ever see them. Naquan Dunbar was a student of mine who always took time to listen. The last time I saw him was at a block party. He had become a little gangster. Later, I would hear that he was killed at a house party around the corner from his home. His brother Dennis and I had hung out back in the days. Another was Brian Davis. He was the younger brother of my partner Tyrone. I always saw great potential in him. It was said that he was shot in an attempted robbery of a crack house. Six of my partners lost their younger brothers prematurely to the violence. Crack brought the highest rate of murder and incarceration of young black men ever.

I was fortunate to photograph many men, women, and children in their best years before crack and AIDS destroyed their communities. The camera enabled me to tell a person how special and valuable they were and I had hoped that I could encourage people to look toward their own futures and believe in themselves.

The 80s allowed me to take some of my greatest photographs, from the joy of life to the pain of death.

Peace,
Jamel Shabazz, July 2001

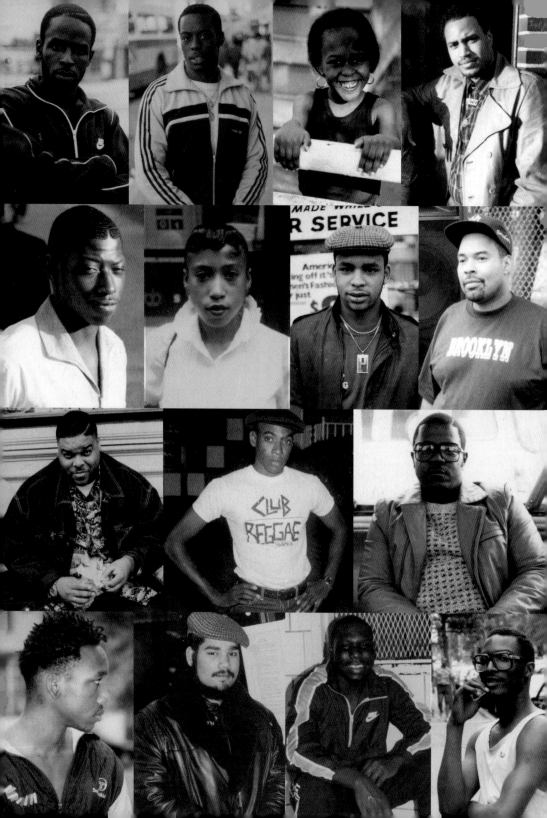

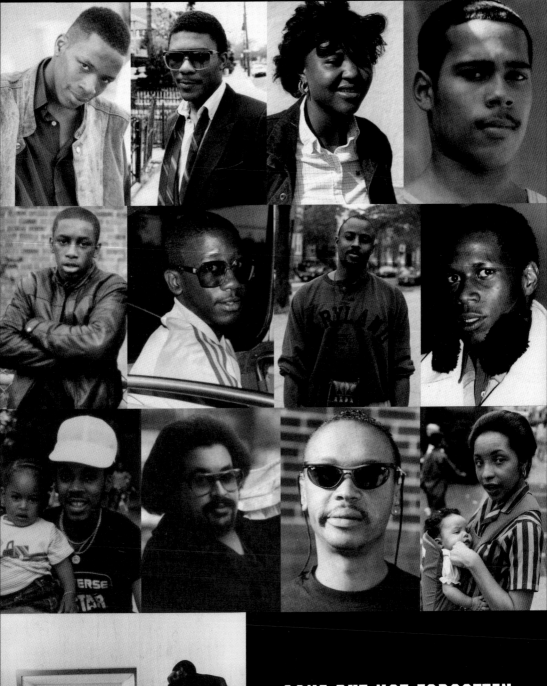

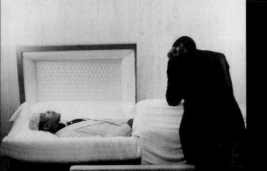

GONE BUT NOT FORGOTTEN

✦

REST IN PEACE

Special thanks first and foremost to the Creator for allowing me to see.

To all the beautiful people who had faith in me and allowed me to photograph them.

To the powerHouse Books family, my family, Eric Russ, Tracii McGreggor, Janene Outlaw, Claude K, Eddie Brannan, The Source Magazine, Trace Magazine, Shabazz: Entertainment, Patrick and the Say it Loud Program, Fab Five Freddie, Big Ernie Paniccioli, Kevin Powell, Zahir, Lamel, AG, PNB Nation, Mass Appeal, Boudicon, Duane Pyous and One World, Honey Magazine, Stress Magazine, Chromazone, Inc., Shahid, Malik, T. Floyd, Tony B, Big Jimmy, Rashawn, Anthony, Dulla, Ramel, Wanique, Black, LaLutta, Loronz Murray, Skip and the Crew, Phil Harris, Utopia, The Fruit, Kelefa Sanneh, Big EJ, Spin and Vibe Magazine, Yuko Uchikawa, Bonz Malone, and Gourdine, Larry McCarthy, Sharpe, Eli Reed, and last but not least, Hamp 33 1/3.

PEACE

JAMEL SHABAZZ WAS BORN IN RED HOOK, BROOKLYN IN 1960. HIS FATHER, A U.S. NAVY PHOTOGRAPHER, PASSED ON THE KNOWLEDGE OF PHOTOGRAPHY TO THE YOUNG SHABAZZ AT THE AGE OF FIFTEEN. FOR WELL OVER 25 YEARS, SHABAZZ HAS DOCUMENTED THE HISTORY AND CULTURE OF AFRICAN AMERICANS AND URBAN FASHION. SHABAZZ'S PRESENT PROJECT IS TO BRING HIS STILL IMAGES TO LIFE IN THE FORM OF LITERATURE AND MOTION PICTURES.

SHABAZZ'S WORK HAS BEEN PUBLISHED IN *ONE WORLD*, *VIBE*, *SPIN*, *TRACE MAGAZINE*, *THE SOURCE*, AND *JALOUSE*, AND EXHIBITED AT *THE TRUE SIGNS* EXHIBITION AT THE GALERIE BEAUREPAIRE IN PARIS, XHIBITION TRANSITION IN CHICAGO, PROSPER GALLERY IN NEW YORK CITY, AS WELL AS AT THE BROOKLYN MUSEUM OF ART'S EXHIBITION, *HIP HOP NATION: ROOTS, RHYMES, & RAGE*.

ONE OF SHABAZZ'S GREATEST JOYS IS PASSING ON THE KNOWLEDGE OF PHOTOGRAPHY TO THE YOUTH. AT EVERY OPPORTUNITY, HE SHARES HIS EXPERIENCE WITH THEM, WITH THE INTENTION OF CREATING A NEW GENERATION OF VISUAL ARTISTS.

BACK IN THE DAYS

Published in the United States by powerHouse Books,
a division of powerHouse Cultural Entertainment, Inc.
180 Varick Street, Suite 1302, New York, NY 10014-4606
telephone 212 604 9074, fax 212 366 5247
e-mail: backinthedays@powerHouseBooks.com
web site: www.powerHouseBooks.com

Library of Congress Cataloging-in-Publication Data

Shabazz, Jamel, 1960-
 Back in the Days: photographs / byJamel Shabazz; introduction and interview by Fab
5 Freddy.
 p. cm.
 ISBN 1-57687-106-1
 1. African American youth--New York (State)--New York--Social life and customs--
Pictorial works. 2. Youth--New York (State)--New York--Social life and customs--
Pictorial works. 3. African American youth--Costume--New York (State)--New York--
Pictorial works. 4. Youth--Costume--New York (State)--New York--Pictorial works. 5.
Hip-hop--New York (State)--New York--Pictorial works. 6. New York (N.Y.)--Social life
and customs--20th century--Pictorial works. I. Fab 5 Freddy, 1959-

 F128.9.N4 S53 2001
 974.7'100496073--dc21

 2001046178

Hardcover ISBN 1-57687-106-1

Separations by Studio Uno, Verona
Printing and binding by Poligrafiche Bolis, Bergamo

Special thanks to Scheufelen North America

A complete catalog of powerHouse Books and
Limited Editions is available upon request;
please call, write, or get fresh on our web site.

10 9 8 7 6 5 4 3

Printed and bound in Italy

GRAFITTI BY ALEX GERPE aka AG

BOOK DESIGN BY YUKO UCHIKAWA